PHOTOGRAPHING YOUR GARDEN

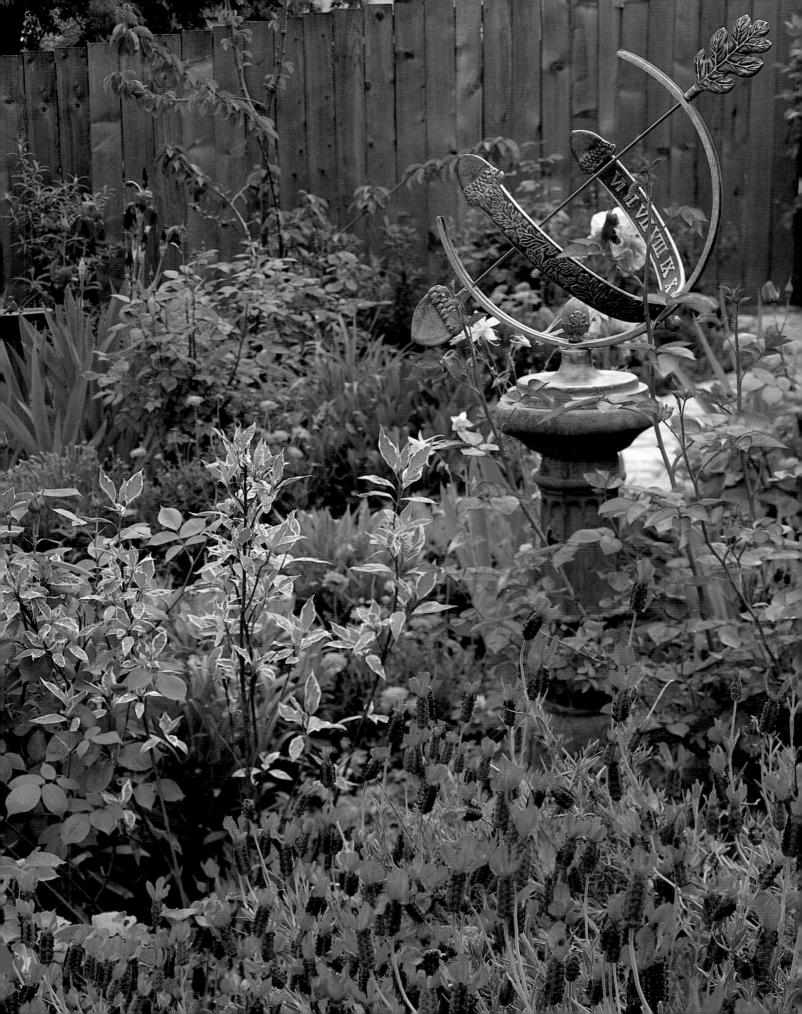

PHOTOGRAPHING
YOUR GARDEN

DAVID BJURSTROM

Sterling Publishing Co., Inc.
New York

Prolific Impressions Production Staff:
Editor in Chief: Mickey Baskett
Creative Director: Susan E. Mickey
Copy Editor: Sylvia Carroll
Graphics: Karen Turpin
Styling: Bill Bloodgood, Laura Reavis
Photography: David Bjurstrom
Administration: Jim Baskett

Every effort has been made to insure that the information presented is accurate. Since we have no control over physical conditions, individual skills, or chosen tools and products, the publisher disclaims any liability for injuries, losses, untoward results, or any other damages which may result from the use of the information in this book. Thoroughly read the instructions for all products used to complete the projects in this book, paying particular attention to all cautions and warnings shown for that product to ensure their proper and safe use.

No part of this book may be reproduced for commercial purposes in any form without permission by the copyright holder. The written instructions and design patterns in this book are intended for the personal use of the reader and may be reproduced for that purpose only.

All photographs copyrighted by David Bjurstrom and may not be reproduced in any form without permission by the copyright holder.

Library of Congress Cataloging-in-Publication Data

Bjurstrom, David
 Photographing your garden / David Bjurstrom.
 p. cm.
 Includes index.
 ISBN 0-8069-6889-3
 1. Photography of gardens. I Title.

TR662 .B58 2002
778.9'34--dc21

2002030397

10 9 8 7 6 5 4 3 2 1

Published by Sterling Publishing Company, Inc.
387 Park Avenue South, New York, N.Y. 10016

Produced by Prolific Impressions, Inc.
160 South Candler St., Decatur, GA 30030
© 2003 by Prolific Impressions, Inc.
Distributed in Canada by Sterling Publishing
c/o Canadian Manda Group, One Atlantic Avenue, Suite 105
Toronto, Ontario, Canada M6K 3E7
Distributed in Great Britain by Chrysalis Books
64 Brewery Lane, London N7 9NT, England
Distributed in Australia by Capricorn Link (Australia) Pty. Ltd.
P.O. Box 704, Windsor, NSW 2756 Australia

Printed in China
All rights reserved

Sterling ISBN 0-8069-6889-3

Acknowledgements

Although I would love to say that all of the photographs in this book were taken in my very own garden, I must confess, that is not true. This work represents a selection of images from many gardens I have been privileged to visit over the past decade. I would like to thank the dozens of gardeners around the country that have allowed me into their lovely gardens.

■ *In particular, I extend a great deal of appreciation to the* **Jackson & Perkins Company** *of Medford, Oregon. I have had the good fortune to work with these fine folks for many years, and their assistance in assembling of this book has been wonderful. www.jacksonandperkins.com*

■ *Also, I wish to thank the* **Brooklyn Botanic Garden***, 1000 Washington Avenue, Brooklyn, NY 11225 for their permission to use photos taken in their spectacular gardens. www.bbg.org*

■ *Thanks to my friends Susan Mickey and Bill Bloodgood who gave me the original idea for this book — to Susan, especially, for giving the project the kick-start it needed and to Bill for his unending encouragement and inspiration as well as his many creative ideas.*

DAVID BJURSTROM

David Bjurstrom has been the primary rose and garden photographer for the Jackson & Perkins Company for over a decade. In that capacity he has received over 15 international catalog awards recognizing excellence in the direct mail industry. His photographs have also appeared in many major publications throughout the United States. He is an avid gardener and brings that knowledge to his photography.

In addition to his accomplishments as a photographer, David is a nationally recognized western artist. His detailed pencil drawings of the people and places of the contemporary American West have won numerous Best of Show awards around the West and can be found in private and corporate collections throughout the world.

David lives in Southwest Oregon and enjoys relaxing in and photographing the majestic beauty of his home surroundings.

Dedication

I dedicate this book to Mom and Dad who have always been supportive in everything I have ever done. Without their encouragement, I could never have achieved anything close to what I have accomplished.

CONTENTS

Pictured right: Rudbeckia fulgida; Kodak E100S, f11 at 1/60th second.

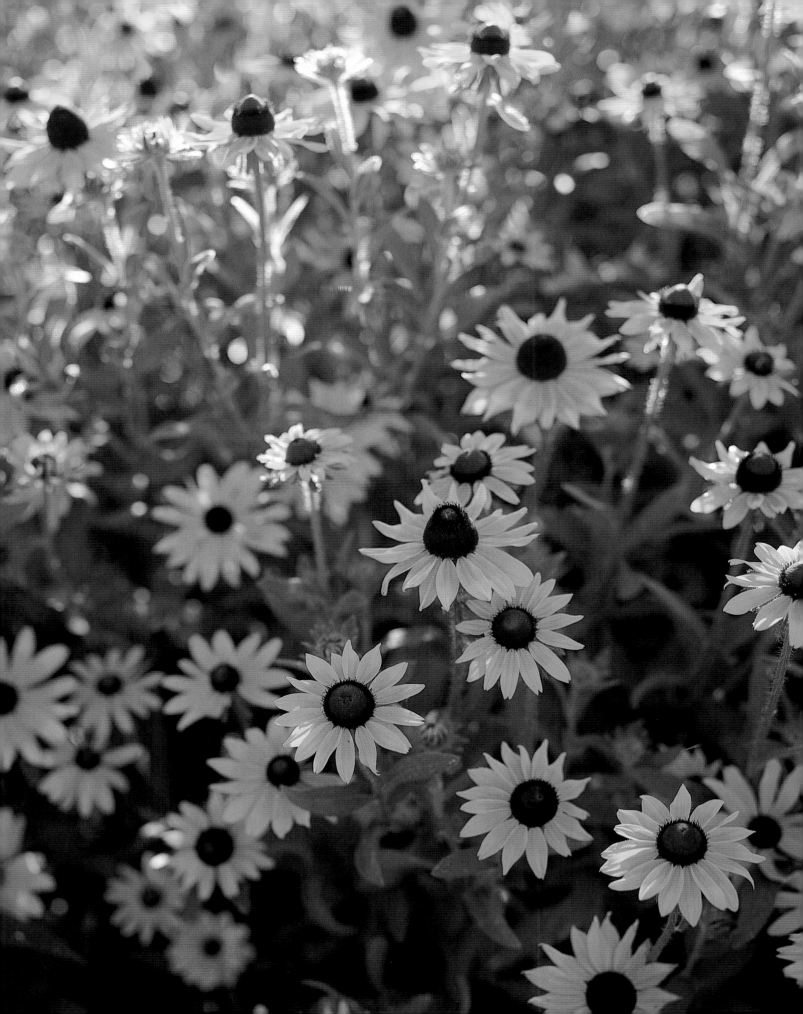

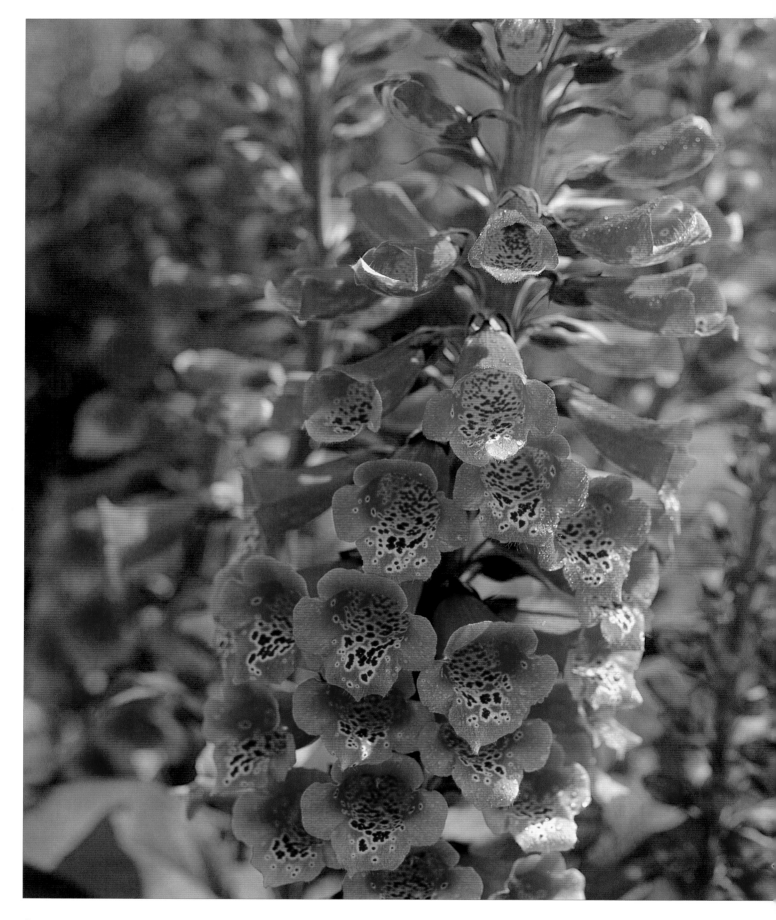

INTRODUCTION

Gardeners and photographers have long been joined together by a love of nature. Gardeners strive for the perfect bloom, the healthiest plant, the most peaceful garden, or simply a unique expression of themselves. Photographers continually search for much the same...an interesting subject, a unique approach, a compelling image, and a creative expression. When the two are combined, the results can be thrilling.

Nature and, in particular, flowers and gardens are often the first subjects of fledgling photographers. There's something about the intricacy and beauty of Mother Nature that drives us to capture it on film. The fruits of a gardener's labors, although often spectacularly beautiful, are but fleeting moments as the blossoms pass and the seasons change, leaving just a memory of the beauty that once was. The way to preserve and share those glorious moments in a plant or garden's cycle is with the camera.

In my many years as a garden photographer, I've learned techniques, often by short experimentation or sometimes long trial and error, that assure me of the results I'm looking for in a great image. Some are simple and really quite obvious while others may seem counter to all the "rules" we learn when first picking up a camera. With this volume, I hope to share some of these techniques to help you improve your own photography.

The information in this book can be applied to any camera equipment you may use from the simplest point and shoot cameras to 35mm SLR systems and even more professional level medium format equipment. Some of the least expensive compact cameras may not be able to give you results just as you see here because the lenses are generally limited. However, by keeping in mind these techniques for composition, lighting and styling, you should be able to adapt to your own equipment without immediately moving up into a more expensive range. Great photography is more about technique than fancy cameras. Occasionally, I may reference a particular brand of camera, film or equipment. Though it may be what I happen to use, this does not imply that it is the only brand and, in fact, there are always many brands and options that may produce the same result. Personal experience and trial and error will be your own best guide.

Happy shooting! ❏

Catching an old rambling rose at just the peak of its bloom can make an exciting image that preserves the plant's beauty well beyond the season.

Fuji Velvia,
f8 at 1/30th second.

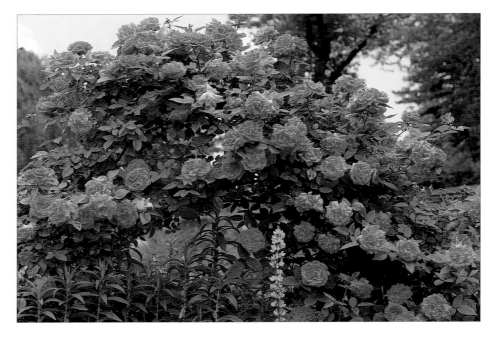

Garden photography is more than just the plants as they grow. It's also about capturing the fruits of the garden and the feel of being in that space, as with these roses in a container on a rustic garden chair.

Kodak LPP,
f8 at 1/30th second.

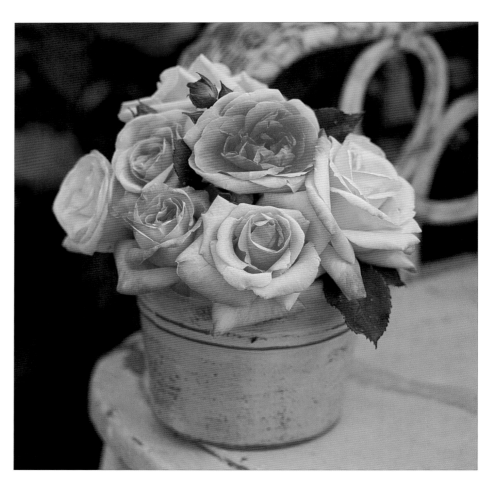

Pictured opposite page: Find the secret places in the garden. They will often yield the surprising images of plants that have grown together for a naturally beautiful composition.

Kodak E100S, f11 at 1/60th second.

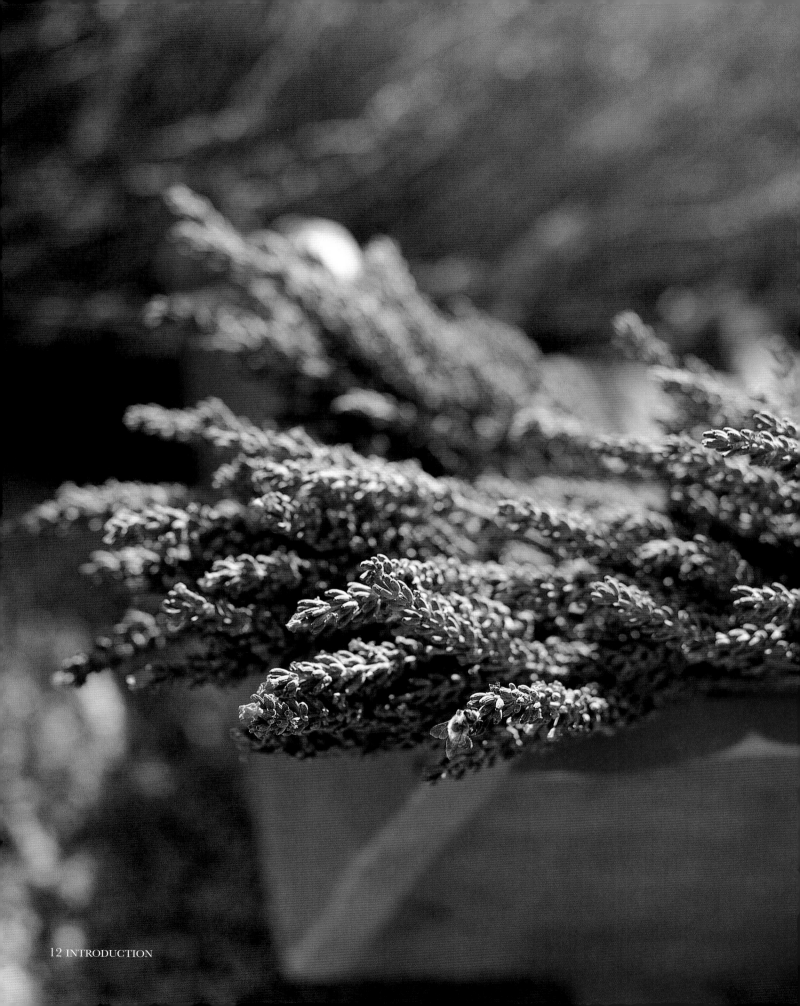

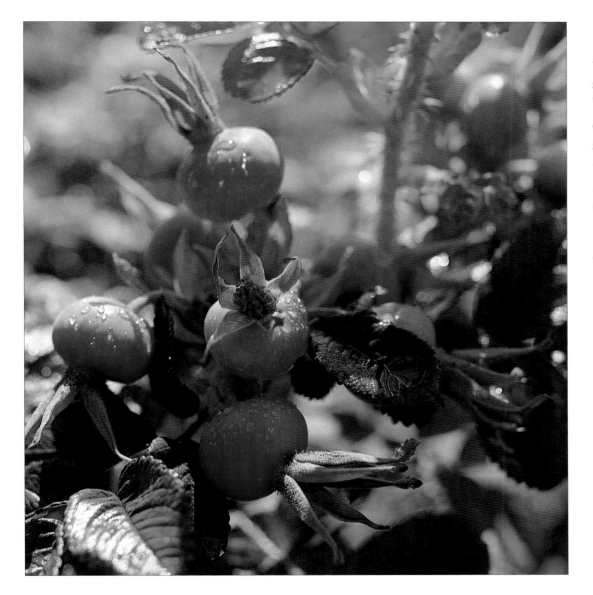

Continue to watch the garden late in the season. Even as the blooms have faded, other spectacular subjects often replace them, such as these rose hips captured in October.

Kodak E100S, f8$\frac{1}{2}$ at 60th second.

Pictured left: Capturing the romance of the freshly harvested lavender, this photograph uses a very shallow focus to give a dreamy quality to the subject.

Kodak E100S,
f5.6 at 250th second.

EQUIPMENT

To achieve the professional results I hope this book will teach you, in most cases you need not purchase special equipment. Within only a few limitations, you should be able improve your photography with almost any camera you already have from a simple point-and-shoot 35mm camera up to the most sophisticated automatic cameras now on the market.

Writing about equipment is a difficult and delicate subject. While better cameras, lenses, and accessories can make flower and garden photography a bit easier, I am above all not an equipment snob. I have somewhat of a loyalty to my brand of camera, but that is really only because I am comfortable with it and have already made the investment in the basic equipment, so I purchase additional pieces that work with that system. I could easily have started with Brand A, B or C and still achieved the same results. Photography is far more about the eye of the photographer and his or her proficiency with their chosen equipment than it is about a particular brand name. For this reason, I will only suggest what will make the craft easier and leave it to you to select equipment that fits your own budget.

Essentially, all you need are a camera with a good quality lens and a tripod. I will, through this text, suggest some additional items such as filters and specialized lenses that will add to your bag of tricks, but don't feel obligated to run out and spend large amounts of money right away. Get your feet wet in the morning dew and find the joys of garden photography. Then, let your creative direction guide you on what to buy and how much to spend. ❏

CAMERAS

Garden photography is possible with any camera you may already own. One may use a simple, compact 35mm camera with a fixed lens, a 35mm single-lens reflex (SLR) camera, a digital camera, or a larger medium format camera. The greatest difference between these many possibilities are the options they offer in terms of their lenses, filters, and exposure as well as, of course, cost. When starting out, use the camera you already have. Become familiar with its operation and refer to the owner's manual for specific information about your particular equipment. Apply the techniques for composition, lighting, and styling as described in this book with your current camera. Once you have become more comfortable in producing wonderful garden images, then you may want to consider upgrading your system to the next level.

Compact 35mm Cameras

- Inexpensive
- Fixed Focus Range
- Auto-focusing
- Off-set Lens

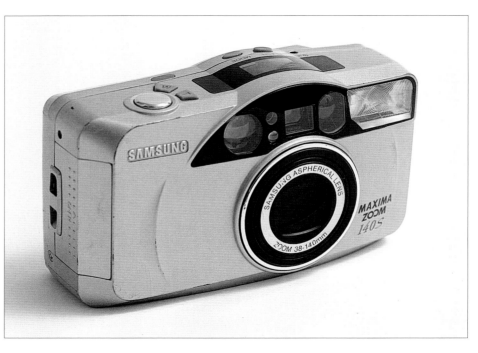

These types of cameras have the advantage of ease of use and, generally are the least expensive. Though easy to use, they have limitations that may soon frustrate you. Generally, they have a fixed focus range. That is, the lenses are configured to focus sharply within only a specific, factory-set area and cannot be manually adjusted by the photographer. In fact, most are auto-focus, which will not allow you to make some of your own creative decisions in that regard. Often, they will not focus closer than around three feet (one meter). This is not a problem for general garden shots but it can make close-ups nearly impossible. Sometimes they do offer close-up settings, but even these can be limiting. The owner's manual of such a camera will give specifications as to minimum focus distance. Additionally, one should be aware that with these cameras, the viewfinder is slightly offset from the lens. That is, you are not looking directly through the lens when viewing your subject. When photographing an object that is fairly close up, you must be sure to move the camera a bit to compensate for the slightly different angle of view that the lens will have.

35mm SLR Camera

- Changeable Lenses
- View Thru Lens
- Manual or Automatic Options

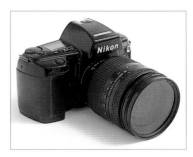

For their versatility in exposure adjustments, lenses and filter availability, the best camera for good, general garden photography would have to be a full-size 35mm SLR. One of the greatest advantages of these cameras is that they have a multitude of lenses available, which will give you much more creative control over your images. Also, when you look through the viewfinder, you are seeing exactly what the lens sees. This is accomplished through the use of a mirror that moves up out of the way when the shutter release is pressed. Many SLRs are fully manual, requiring the photographer to select the shutter speed, lens aperture and focus while others offer a fully automated, computerized system to make these choices for you. Generally, those cameras with the automatic features also can be used in a completely manual mode, if desired. Today's sophisticated programs in the automatic modes are almost foolproof. It is only in the trickier lighting situations which I'll discuss later in the book that manual control over the electronic systems becomes necessary.

Medium Format Camera

- Professional
- High-Quality Enlargements
- Manual Operation
- Expensive

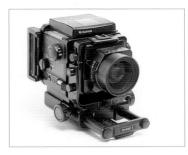

An option for the more advanced photographer, serious about producing the best possible images is to use a medium format camera. Medium format refers to the larger film size that is used and, therefore, the resulting larger negative or transparency. These cameras generally use 120mm roll film. The greatest advantage is that these images can be enlarged to much greater sizes than is really possible with 35mm film, without losing quality. They come in many configurations. Some appear as oversized SLRs with similar features and others have an entirely different look with a capability for lens shifts, swings, and focus usually available only in studio cameras. They are most often the camera and format of choice for professionals.

Throughout this book, I have used both my 35mm SLR and my medium format camera to produce the images you see here. Occasionally, I have even included some images shot on a large format 4x5 studio camera. Though I will point out the equipment used when it matters, it almost never has much bearing on the techniques discussed. This book is about achieving good photographs using a sense of aesthetics rather than using a specific piece of equipment. Always refer to the owner's manual for your camera and become familiar with its operation. If you are comfortable with it, there is nothing left but to take great photographs.

Digital Cameras

- Variety of Prices
- Immediate Photo Image
- Versatile
- Requires a Computer and Printer

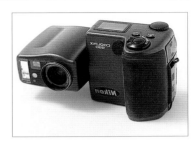

Digital cameras come in many forms and many price ranges. They can be nearly identical in the basic features (and limitations) of compact 35mm cameras or they can be as sophisticated and versatile as a 35mm SLR with interchangeable lenses and various settings. They are available in a range of image quality capabilities. Those with the higher number of pixels on the image sensor will produce a higher quality, larger image. Of course, with more sophistication, comes a much higher price tag. Their greatest advantage is the immediacy of seeing your image as soon as you've taken it, usually with a preview screen right on the camera. This allows for much less guesswork and a greater ability to change the shot or take several versions. You can delete the ones you decide not to keep without a bit of expense for film. A digital camera will, however, require a computer and printer or, at the very least, a digital image printer that can be connected directly to the camera if you wish to have a "hardcopy" photograph. ❏

LENSES & FILTERS

Lenses come in an almost overwhelming variety of focal lengths ranging from 15mm wide-angles to telephoto lenses of 600mm or more. Thankfully, the range useful for garden photography is relatively small. This will simplify your task of selection.

Three Lenses for Versatility

In most cases, your camera's standard lens is perfectly good. For a **35mm SLR**, that would be a focal length of **50mm**. Sometimes one might find themselves in a situation where there is very little room to back up in order to capture an entire garden scene. In this instance, a wide-angle lens of 20 or 28mm may be needed. In general, you will probably not need a lens with a focal length greater than 100 to 135mm for any garden photography, though you may desire a longer focal length as you become more advanced.

I recommend three fixed focal length lenses – a 20mm, a 50mm, and a 105mm lens. An important feature that should be built into these lenses, however, is a macro or close-focusing capability.

Lenses without this ability can usually focus at a point no closer than three feet or more from the front element. To achieve wonderful close-up shots of blooms or other plant features, you certainly will want to be able to get much closer and macro lenses will allow that. In most cases, you will be able to get within a few inches of your subject. If you cannot afford macro lenses, a less expensive option is to purchase a set of close-up filters that attach to the front of your lens. They work much like reading glasses, magnifying the subject. Though often inexpensive, they usually produce some loss of image quality, and that can be critical when shooting a close-up subject. I prefer to spend a bit more up front on a true macro lens.

Zoom Lenses

An alternative to having three fixed-focal length lenses, is to use **zoom lenses**. Although fixed lenses tend to be of better quality overall, zoom lenses are now coming into their own and really do rival their fixed length cousins. They can be found in ranges of **28-70mm** covering the wide to normal ranges and in the **70-210mm** length covering the telephoto range. A favorite lens of mine is a **28-200mm zoom**, which covers the entire range with just one lens. In fact, it is the single lens I use most often.

Many zoom lenses now have a macro capability, as does my 28-200mm zoom. However, some zoom lenses will only have the macro ability at the widest zoom while others will close focus throughout the full zoom range. Carefully check this capability with your dealer prior to making a purchase so that you fully understand what the lens will do for you.

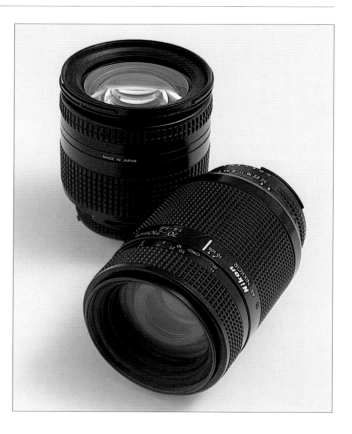

Extension Rings

If your lenses do not have a macro capability, another approach can be taken to increase magnification by allowing the lens to come in closer to the subject. Using extension rings that fit between the camera body and lens will do just that. The rings come in fixed lengths and it is possible to combine them for even greater levels of magnification. I have a set of three I use with a 400mm telephoto lens when photographing birds or insects in the garden. That allows me to get closer than the usual minimum focusing distance of the lens and produce highly detailed close-ups of my subjects without getting so near as to scare them away.

Filters

Along with the lenses, a few filters will enhance your photographs and are certainly worth adding to your camera bag. The most useful would be a **polarizing filter**. It will help reduce unwanted glare on reflective surfaces and increase saturation of colors, intensifying them for a more dramatic appearance. These lenses are adjustable and you should always experiment with the degree of polarization for the effect you want. Polarizing filters also reduce the amount of light reaching the film, which will require a longer exposure or a wider lens aperture.

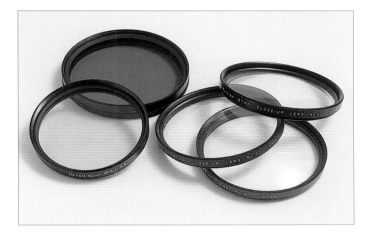

Color compensating filters may also be used to change the color balance of the light on your subject. They may only be used with slide films, however, as they will have little or no effect on print films due to the developing and printing processes. Generally, with garden photography, you will not want to change the colors in any significant way, but some of the most helpful filters I use when shooting slides is the 81 series. This series of filters includes a pale to deep gold color that warms light in a very pleasing way. Unless shooting in midday sun (not good, as I will discuss later in the book), outdoor colors can take on a cool cast, especially in shaded areas. For this reason, as a standard practice, I use an 81A filter on the front of my lens. This adds a very pale warming effect. If I happen to be shooting a shade-loving plant where the light is very cool, I will sometimes use an 81C or 81D filter which adds a significant amount of warmth to the scene. These filters, when used judiciously, compensate for an overly cool blue light in shadow areas that give the plants an unnatural and uninviting appearance.

The only other filters that you may wish to experiment with are those that add special effects such as **star filters, prismatic filters, or soft focus filters**. Each can add an interesting look, but would not be used for true horticultural photography.

Price

Whichever lenses you choose for your system, I would always recommend that you purchase the best quality you can afford. In camera lenses, as with most anything else, you really do get what you pay for. If a particular lens seems too expensive for your budget, consider purchasing it used. This can almost always be done for a fraction of the new price. When doing this, however, be sure you are able to test the lens to make sure it is in good working order before making your final commitment to purchase it. ❑

TRIPODS

Tripods and monopods or other sturdy, solid supports for your camera will provide the ability to use slower shutter speeds while shooting in the garden – that is, speeds generally slower that 1/60th of a second. As I will discuss later in the book, slower shutter speeds will allow you to achieve a greater depth of field, which is especially critical in close-up work. Almost any tripod will work for your garden photography, however, you will find it very helpful to have one that will allow a camera position that is as low as possible. I often find myself setting up the camera only a few inches above ground level.

Primary Tripod

I have three tripods and one monopod that I use in varying garden situations. My primary tripod is the largest of the three. It gives me great versatility in how high the camera may be positioned, from very low with the legs splayed wide, to quite tall for high views and taller plants and blooms. Each of the legs can be adjusted independently in both their length and angle, which is very handy in rough or sloping ground. The controls for camera movement are large and easy to grasp. They provide independent control for camera tilts forward and back as well as sideways to change the picture format from horizontal to vertical or any point in between. Other than my camera and lenses, it is the one piece of equipment that makes most of my work possible. The greatest drawback is its size and weight, making it less than ideal for extensive travel.

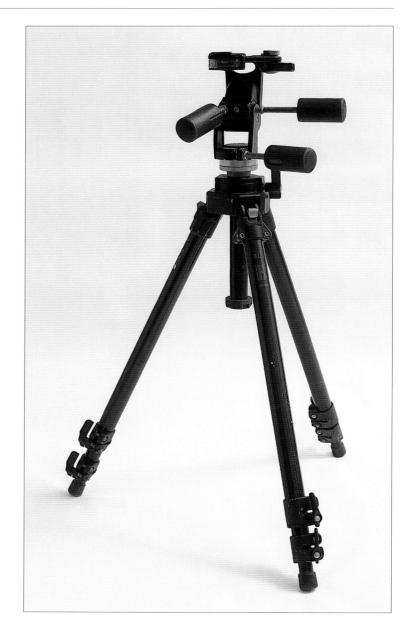

Travel Tripod

For travel, I have a smaller tripod with most of the same leg and camera movements. It is just shorter and lighter, meaning it packs much more easily for travel. The camera mounting head is known as a ball-mount. The control for camera tilts is reduced to just one small handle which, when loosened, allows the camera to "float" freely in any direction. Once you are in

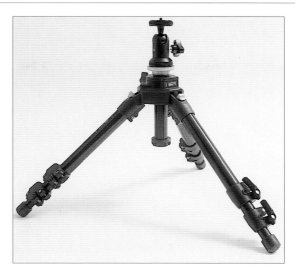

the desired position, tighten the one handle and that's it. Although it is very much like my general-purpose tripod, the real limitation is its size. It will not extend nearly as high, and that can sometimes be a bit of a handicap. I often find myself setting it on benches or a table to achieve extra height, which works, but such supports aren't always readily available.

Small Tripod

My third tripod is very small and lightweight. It can travel easily and works well in a pinch. It is a pocket tripod designed for being set on a rock, table, bench or other available surface. It is also perfect when a very low camera viewpoint is needed and

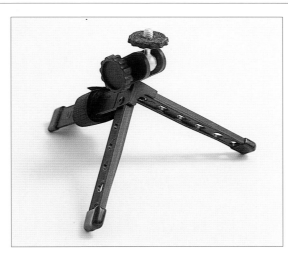

no other tripod can be set that short. Because of its size, it has limited application but can easily be carried along anywhere and has, on occasion, saved me a bit of trouble when another tripod just wasn't available or couldn't be used.

Monopod

The last of the camera supports I have is a monopod, which, as the name implies, has just one leg rather than the tripod's three. It is handiest when you need just a little more steadiness than hand holding can provide. It cannot be used for very long exposures but is good for shutter speeds of around 1/8th to 1/30th of a second. It is also very handy to

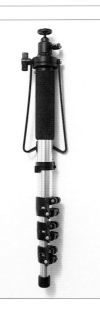

steady the camera when a longer focal length lens is being used since they can sometimes cause unwanted movement just from their weight on the front of your camera. The greatest advantage is ease of set-up and portability. The disadvantage is that it cannot be used for long exposures. ❑

ADDITIONAL EQUIPMENT AND ACCESSORIES

In addition to the equipment we've looked at up to now, a few more items will help you accomplish the shots you want with greater ease. As you progress in your garden photography, you may find additional items that will assist you. The following items are merely a starting point.

Photographer's Vest

One of the most helpful accessories I own is my photographer's vest. It has a multitude of pockets and pouches in which I am able to carry all the little things I need without having to put them in a separate carrying bag. There are pockets for film, extra lenses, filters, a note pad and pen as well as most of the small styling tools I will talk about in a later chapter. In fact, there are so many pockets I sometimes have to really think about where I might have stashed what I need. I won't leave home without it, even if I'm only going into the back yard.

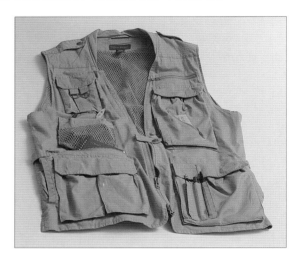

Notepad & Pencil

Among some of the small things you should always carry along is a note pad and pencil. It is very important to write down what you have photographed and where so you have a record later when sorting through your shots. When taking notes, write the photo number (from the counter on your camera), the subject (variety and name) and, if you wish, some technical information such as the shutter speed, f-stop, and lens focal length. These may seem like pesky items to note, but it is especially helpful while learning to be able to look back on your notes and find out just how you did that wonderful shot. Also, when you have the film processed and a photo did not turn out as you expected, you can look back and see what you did to determine how to avoid that problem next time. And, above all, you want to be able to use these notes to identify your photos later.

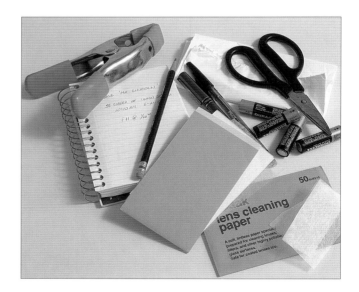

Things to Note:
- Photo number
- Subject
- Shutter speed
- F-stop
- Lens focal length

Large Cards, Stand, Clamps

A few other items you may want to have handy for outdoor shooting are some large cards to block breezes and a stand and clamps to hold them up. It is a rare day to be photographing in the garden when the air is absolutely still. If there is even a small breeze, it can move foliage and flowers enough that you will need to use a faster shutter speed to get your shot. Sometimes, because of less than bright light, that is not an option, so the best thing to do is introduce something to block the air movement. If it is just a small breeze coming from behind you, your body may be enough. However, if it is coming from the side, placing a large card made of foam core board or posterboard clamped to a stand may be enough to keep your subject from moving.

The clamps I use are known as 'A' clamps (for their shape) that come in two sizes and are rubber tipped. I always carry a couple of each size as I never know when I'll need that third hand to hold something up or out of the shot.

In addition to the cards blocking the air movement, you will want to have some fill cards or reflectors available. These, as I discuss more in a later chapter, are used to modify the light and improve the ultimate photograph. These fill cards can be nothing more than the same white foam core board or other white board used for blocking air movement. If the air is coming

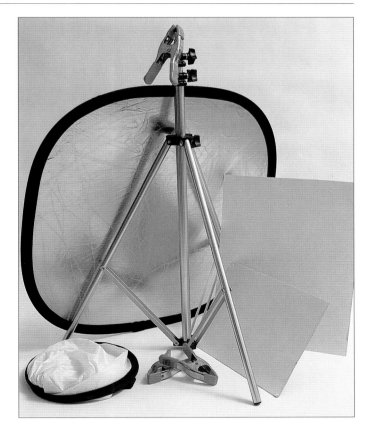

from the right direction, one board may serve both purposes. I have some pop-out cloth reflectors that I often use rather than a card or board. The advantage of these is that they can be folded down into a smaller space for transportation.

Plastic Bags

It's also a good idea to carry a few small plastic bags to cover your camera and lens in case of an unexpected rain shower. Being out in the rain isn't really that much fun, but it is a time when many plants and flowers look their absolute freshest and best.

Batteries

Extra batteries for the camera are also essential to carry along.

Lens Cleaning Cloths

Don't scratch your lens by using paper towels or other abrasive items. Always use lens cleaning tissues and fluid designed specifically for that purpose. By all means keep your lens clean for optimum photo quality. ❑

FILM

There are nearly as many kinds of film as there are subjects and photographers to shoot them. I will discuss the three basic types – color negative, color transparency, and black and white. I have my own favorites, mostly because I have used them for many years and know just what to expect of each. My best advice for anyone just starting is to try as many films in as many situations as possible and learn which one suits your taste best.

The films I use are almost all considered "professional" films. The primary difference between these and consumer films are a very precise color balance and consistency from roll to roll. They also require careful handling and storage to avoid color shifts or other damage to the film. Consumer films, on the other hand, are designed to stand up to less careful handling and still retain very good characteristics. Because of the sturdiness built in, the trade-off can be minor shifts in your results with these films. However, unless the film has been mistreated with too much heat or other improper care, it will probably be unnoticeable. Most local camera supply stores will have a good variety of consumer film available and little if any of the professional films. Do not concern yourself too much with this issue. I have often used consumer films for commercial jobs when I didn't have the "pro" type available. The untrained eye would be hard pressed to tell the difference. I will always try to give you the consumer version name when I mention a professional film.

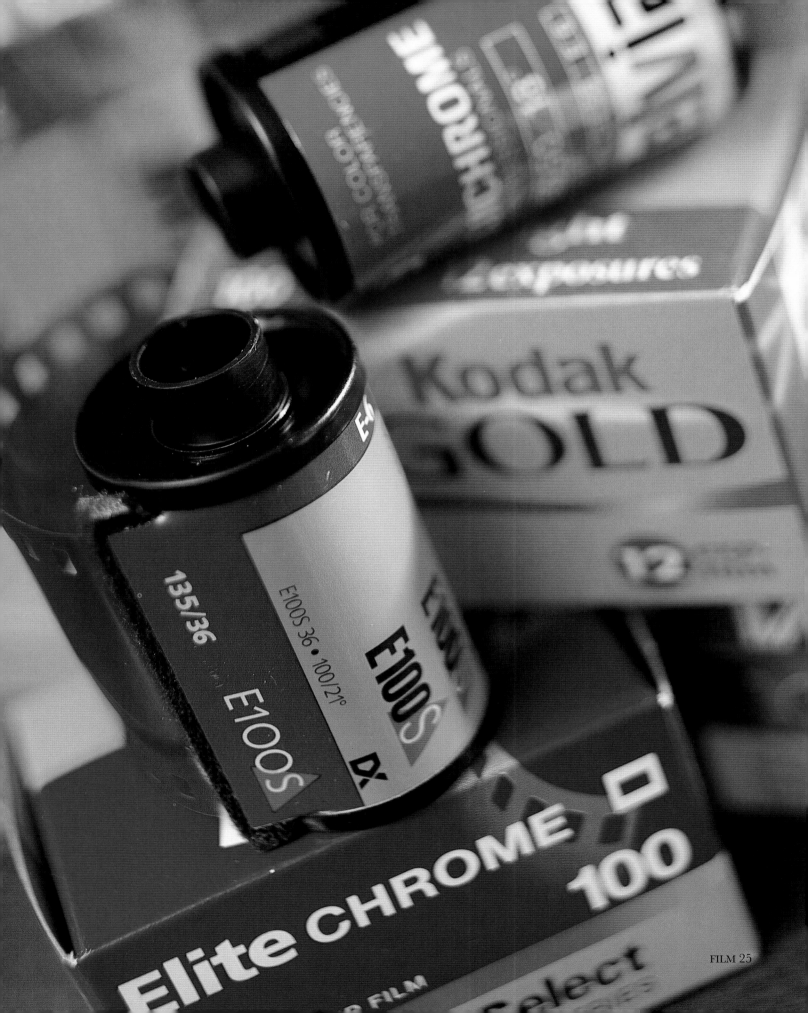

FILM TYPES

There are three basic types of film: color negative or black & white negative (both for prints) or transparency (slide) film. Of these three, the most popular with amateur photographers is, by far, color negative film.

Color Negative Film

For the amateur photographer, having color prints in hand makes it much easier to enjoy and share the results of your photography. Negative films also have greater latitude for correction during processing of errors in exposure. The added benefit is that most film labs will also offer, for a nominal charge, to place your images on a photo CD at the time of processing. This can be very helpful for not only sharing your photos via e-mail or on a web site, but you will also, with a computer and good printer, be able to make much creative use of your garden photography. A drawback to color negative films is that the lab where you have them processed and printed can make an enormous difference in the quality of the prints. Most local or "one-hour" labs run the film in batches, print them with automated equipment, and trim and package the prints with barely anyone looking at them. Unless the system is closely monitored, the final color can be far from accurate. You should always carefully examine your prints and, if they appear to be inaccurate, ask the lab if they can reprint the image for better color. When you find a lab that gives you consistently good results, stay with them.

My Choice:

Kodak Gold 100
ISO 100
Very good color and fine
grain. Good for general
garden photography.

Color Transparency Film

Color transparency, or slide film, is what most professionals use if the images are meant for reproduction in books or magazines. This film is less convenient for casual viewing as it requires some form of projection. It also is far less forgiving in errors of exposure than is negative film. A great positive, however, is that you will almost always have very good color and sharpness with a properly exposed and processed roll of film. If I were to compare a good print from negative film and a good slide, the slide would always win in my judgement. Prints and enlargements can be made from slides, but you should look for a good quality professional lab for this work as it can be more complex than prints from negatives. Slides can also be transferred to a photo CD by your lab for later use with a computer. Unless specifically noted, all of the images in this book were shot on transparency film.

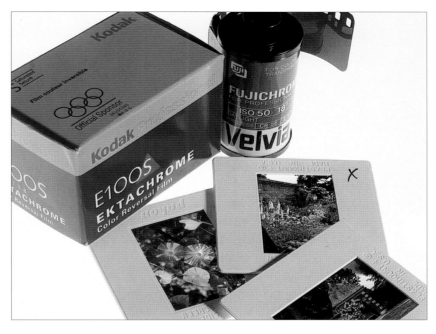

My Choices:
Kodak Elite Chrome (Kodak E100S is the professional version I use)
ISO 100
Excellent color reproduction and fine grain. Good for general garden photography. I use this film in its professional version more than any other film.

OR
Fujichrome Velvia ISO 50
Very saturated color for brilliant images and it has an extremely fine grain. Excellent for overcast days when it will bring out brilliant color. It is a slow film that can be challenging under less than perfect conditions.

Black & White Film

Finally, though you may think it odd for garden photography, black and white negative films can be used. I have seen some very striking black and white images of gardens and flowers. This requires a closer eye as to the light and shadow contrast in your subjects, but it can prove to be very rewarding to photograph a perfect bloom and reduce it from vibrant color to a subtle range of gray values.

My Choice:
Kodak TMAX 100
ISO 100
This is a very good film for general black and white photography with good sharpness and fine grain.

FILM SPEED & GRAIN

The film you select for your garden photography will have an enormous effect on the results you achieve. There are dozens of films available and each has specific characteristics designed to enhance particular photographic subjects.

Color Balance:

Some films have a very neutral color balance. That is, they do not emphasize any particular colors of the subject. Other films may be designed for a greater color saturation that results in increased brilliance of color and contrast. For garden photography, I tend to use films with a higher color saturation simply because, in most cases, gardens are about color. I want to capture that brilliance and freshness. More neutral films leave the gardens looking somewhat flatter and less interesting.

Speed:

All films also have a specific speed rating – that is, sensitivity to light. A film that has a relatively low light sensitivity is considered "slow," while another film that is highly light sensitive is considered "fast." This light sensitivity is given a numerical value known as the ISO number which is always noted prominently on the film packaging and film canister. The higher the number the faster or more light sensitive the film. For example, a film with an ISO rating of 100 is faster than one rated at 50. Likewise, a rating of 400 means that film is faster than one rated at 100 or 200. Slower films will require slower shutter speeds or larger apertures or a combination of both. For my photography, I rarely use film rated faster than ISO 100 and will use slower films if possible. This is to minimize the film's grain.

Grain:

In general, the faster the film, the more prominent the grain will be in that film. Film grain is a factor of its manufacture and is present in virtually all films. For a standard size print, the grain may not be very evident. But, as soon as enlargements are made, the grain can become very distracting and starts to show as tiny, individual flecks of color as the enlargement size increases.

You will want to use the film with an appropriate color balance and one with the least possible grain, therefore, select a film with the slowest speed for the conditions under which you are shooting. This is the greatest challenge you will face because you will almost always encounter some air movement when shooting outdoors. This will translate directly to subject movement. Using a slow film, as we know, means a slower shutter speed, which increases the chances of having a blurred image. The shooting conditions will dictate how fast your film needs to be. This is something you can only learn through trial and error. After a while you will develop a good feel for the conditions and, therefore, the appropriate film speed.

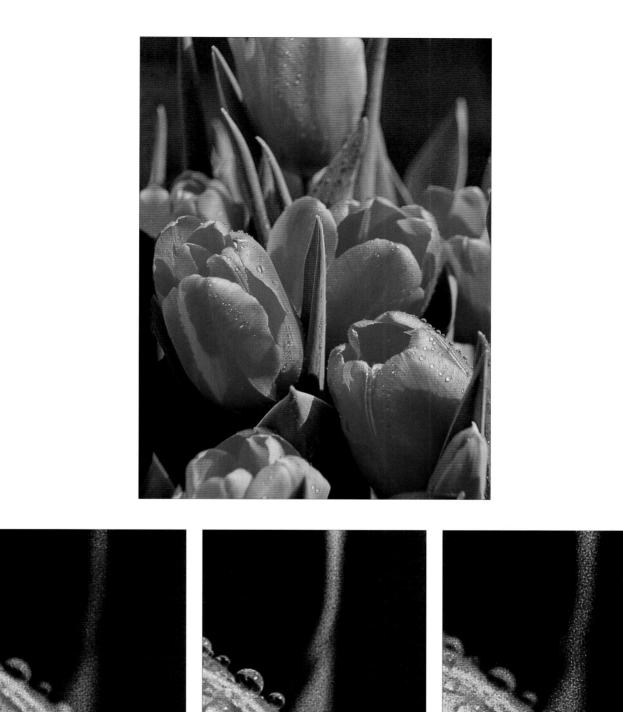

These sections from 8 x 10 enlargements of the top image that were taken with three different films, show how the grain becomes more evident as the film speed increases. From left to right they represent films with ISO ratings of 100, 400, and 800.

CAMERA SETTINGS
&
FILM EXPOSURE

Proper exposure of the film will make or break any photograph. Unfortunately, there is no one correct exposure for every subject. Each situation is different and requires its own solution.

The proper exposure is achieved when the shutter speed and lens aperture are in balance and appropriate to the film speed being used. Today's modern electronic cameras have built-in exposure meters that have become very sophisticated. Their computers immediately analyze the image coming through the lens and, based on thousands of pre-programmed scenarios, make an instantaneous decision about the proper shutter speed and aperture to use. They are often very good at making the correct decision, however, they are not perfect and can be fooled by unusual or tricky lighting conditions. These can include strong backlighting or a subject that is either very light or very dark against a contrasting background. The metering systems usually have two or three modes that can analyze the entire image area, give a heavier emphasis on the central area, or read only a tiny spot in the center of the image. You should become familiar with the metering system in your particular camera from its user manual.

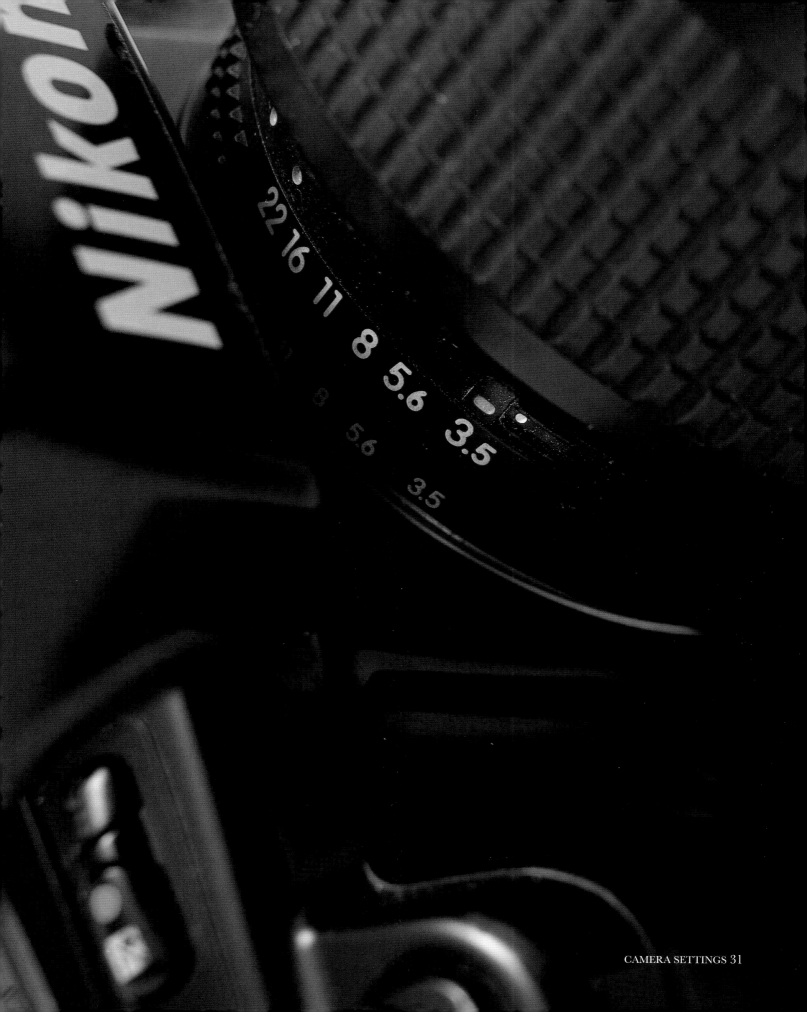

LIGHT METERS

An in-camera or through-the-lens meter is all you will need in most situations. However, if your camera does not have an internal system, you will need an external, hand-held exposure meter. These meters can be either battery-powered electronic models (as I use) or non-electric types that don't require batteries. They are aimed at your subject and take a reading, very similar to what a meter within the camera would do. They can also take a reading from in front of the subject while pointed at the light source. Either method will give you a reading that provides an approximate exposure to use.

Meters

Whether in the camera or hand-held, meters give readings based on an average tonal level equivalent to 18 percent gray. That is, on a scale of zero to 100, where white is zero and black is 100, the gray is 18 steps from the white. This percentage is based on the idea that most scenes, when reduced to a simple monochromatic level, represent that level of gray. In the real world, though, your subjects are rarely that simple and that is why a light meter can be fooled.

With experience you will begin to understand exposure compensation necessary from what the meter tells you.

What is an F-stop?

The shutter is actually a system of metal leaves within the lens that open and close. **The opening within the shutter is known as the aperture. The size of the aperture is measured in f-stops.** The larger the aperture, the smaller the f-stop number will be and, likewise, the smaller the aperture, the larger that number will be. That is, an f-stop of 5.6 is a larger aperture than an f-stop of 8, and an f-stop of 32 is smaller that an f-stop of 22. This may seem a bit counter-intuitive at first, but with time your understanding of this system will be second nature to you. The next important bit of information to understand is that each time the aperture is opened one f-stop, it allows double the light through the shutter. For example, f22 allows twice as much light to reach the film as f32 and f16 allows double the light of f22 and four times as much as f32.

Here are typical f-stop numbers you will see on most lenses. The range on your lenses may vary, depending upon how far open or closed the aperture may be set.

5.6
8
11
16
22
32

REMEMBER
• The smaller the number, the larger the aperture.
• With each step up the light is cut in half.
• With each step down the light is doubled.

What do Shutter Speed Numbers Mean?

The **shutter speed is the amount of time the shutter opens up** to the selected aperture, allowing light to reach the film. The shutter speed numbers refer to the fraction of a second the shutter is open. That is, a shutter speed of 60 on the scale means it will be open 1/60th of a second. Generally these fractions are expressed in whole numbers on your camera's shutter speed setting; 30 for 1/30th, 60 for 1/60th, 125 for 1/125th, and so on. These shutter speed settings are similar to the f-stop settings in that one step in either direction either doubles or halves the shutter speed and, therefore, the light reaching the film.

Here are some of the standard shutter speed settings you will find. Most cameras will have faster and slower shutter speeds beyond this range.

8
15
30
60
125
250

REMEMBER:
- The numbers refer to the fraction of a second the shutter is open.
- The smaller the number, the longer the exposure to light.

Balancing F-stop and Shutter Speed

Because both the shutter speeds and f-stop settings increase and decrease at the same rate, the identical film exposure can be achieved using varying combinations of these settings. Let's say the correct exposure for a given shot is f11 at 1/60th of a second. If you wish to shoot at a higher speed, say 1/125th of a second, which is twice as fast, you could then use an aperture setting of f8 which is double the size of f11. At the same time, you could also use a shutter speed of 1/250th with an aperture of f5.6. One step faster in speed equals one step wider open for the aperture and vice versa.

An understanding of the relationship between the aperture and shutter speed will be very important when we discuss depth-of-field later in the book.

Proper exposure is really as much a matter experience as it is a mathematical formula. Once you are familiar with how your camera's meter readings compare to the final printed image, you will be more able to judge the exposures to meet your liking. If, however, you make it a habit to bracket, you will almost always achieve the correct exposure.

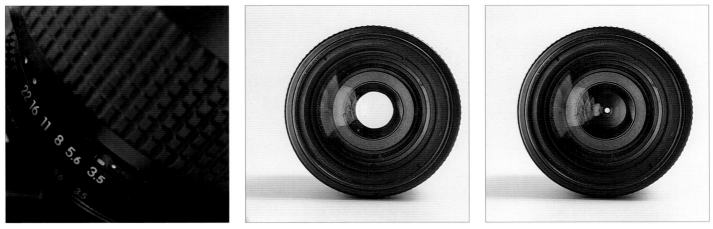

The aperture is set using the ring at the back of the lens.

The setting changes the size of the lens opening as can be seen by looking into the back of this lens with an opening of f5.6 on the left and f22 on the right.

Bracketing Technique

In order to achieve the best possible exposure of my subject, regardless of the metering system used, I almost always bracket my exposures. Bracketing is the technique by which you manually expose the film in three or more frames, both under-exposing and over-exposing from the meter reading. This can easily be done in a couple of ways.

The first and easiest way to bracket is to vary the f-stop. Do this by taking a reading of your subject and expose one frame at this reading. Then expose two additional frames with the aperture set at 1/2 stop under-exposed (toward the larger numbers) and 1/2 stop over-exposed (toward the smaller numbers). In the case of a subject that has a great deal of contrast, you may want to expose 1 stop and 1/2 stop both under and over the meter reading. The second bracketing method is to stay at the same f-stop for each of the frames and vary the shutter speed to the next higher and lower setting from the meter reading level. ❑

 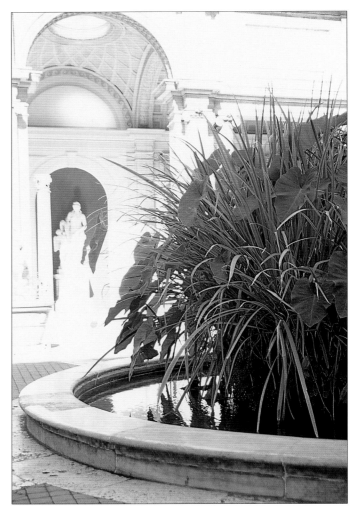

These two shots illustrate the difficulty of exposure when there is a great deal of contrast between your subject and the background. While the image on the left is exposed properly for the background, the subject is far too dark. The photo on the right has a much better exposure for the plant but the background is over-exposed. In this case, bracketing was essential as the camera meter would have averaged the light on the background and foreground resulting in an exposure that would not have been acceptable for either.

These three photos of tulips show the results of bracketing, allowing me, after the film is developed to select the exposure that best pleases me.

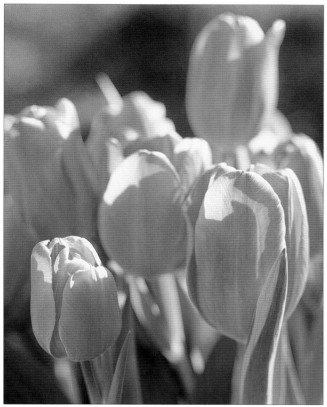

Kodak E100S, f8½ at 1/60th second.

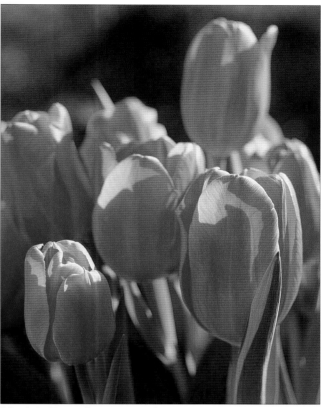

Kodak E100S, f11 at 1/60th second.

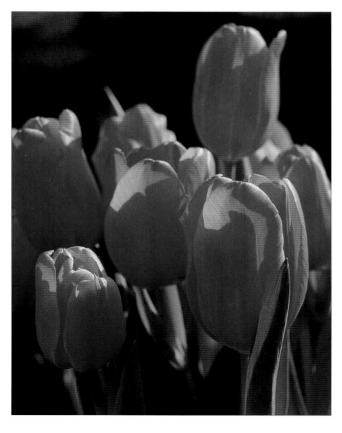

Kodak E100S, f11½ at 1/60th second.

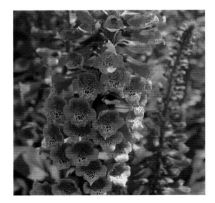

COMPOSITION

Once you are familiar with your camera equipment and have selected the film to use, it's time to start creating photographs. Just about the most important part of creating an image is composition – that is, the design of the photograph. You will be considering the elements you are photographing and how they fit within the frame of your photograph.

This includes learning to see potential subjects that you might otherwise overlook or to see a common subject in a new way. It might be a beautiful bloom or it might be an obscure, tiny garden element that, when isolated in a photograph, becomes highly intriguing. Get yourself to "step out of the box" and look at your garden in creative and sometimes nontraditional ways. Composition also is a matter of framing your subject, placing it interestingly within the frame, isolating it and separating it from the background, and eliminating potential distractions.

In the following pages within this chapter, I will show a "gallery"' of my garden photographs to illustrate various considerations within the broad topic of composition. I hope my commentary will assist and inspire you in making interesting choices in your own photography.

SEEING THE SUBJECT

Although photographs of an entire garden in glorious full bloom can be stunning and memorable, I enjoy finding the elements of the garden that are often overlooked. An unexpected close-up, the simple tomato plant that we rarely see as an ornamental, a simple garden border fence, or birdbath frozen solid in the winter.

Learn to free yourself from the boundaries of "what a photograph should be." Try to visually edit the view into smaller sections. Break it down into its parts. A wonderful exercise, and something I often do, is to go into the garden without a camera. Walk around and look at all that is there. Really see it. Get down on your hands and knees. Use your hands to "crop" the view, blocking out the unnecessary elements. Remember that the camera has a limited view. It does not take in everything at once as your eyes do, so try to look at the garden the same way. It may surprise you what simple things now become very interesting. Once you have taken a close look, pick up your camera and go back out to capture some of the images you've seen.

Pictured above: The pistil and stamens of a rose in this extreme close-up make a surprising and beautiful image that is not commonly seen.
Kodak E100S, f16 at 1/8th second.

Pictured below: This simple bamboo fence, though interesting, is rather unremarkable when photographed from a distance. Coming in close with the low morning light coming from behind gives it a much more abstract look and far more interesting composition.
Kodak E100S, f5.6 at 1/15th second.

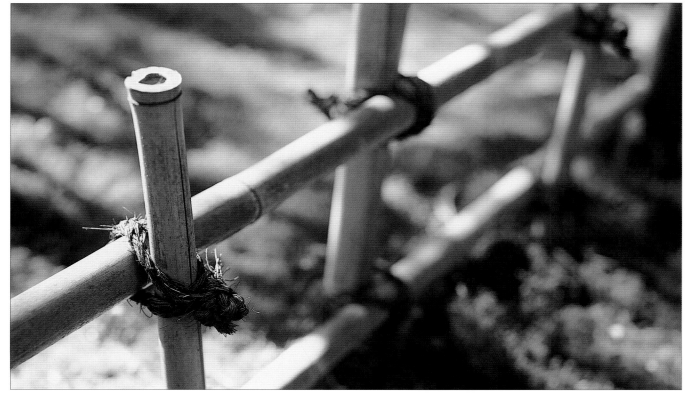

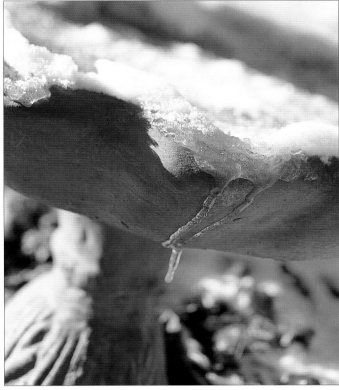

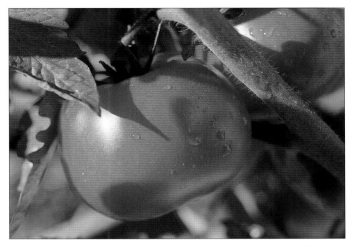

Pictured above: Don't limit yourself to flowers when it comes to photographing the garden. Fruits and vegetables such as this tomato can be luscious photographs that bring back the memories of summer well into the winter doldrums.
Kodak E100S, f11 at 1/60th second.

Pictured above: Like the border fence, this birdbath is not terribly interesting when looked at from a distance. However, a close view that cuts off the edges and a focus on the tiny icicle and dribble of ice give it a very intriguing look.
Kodak E100S, f5.6 at 1/30th second.

Pictured below: Try to capture plants as they grow, especially if they are in an unusual situation such as this clematis growing on the trunk of a tree.
Kodak E100S, f8½ at 1/60th second.

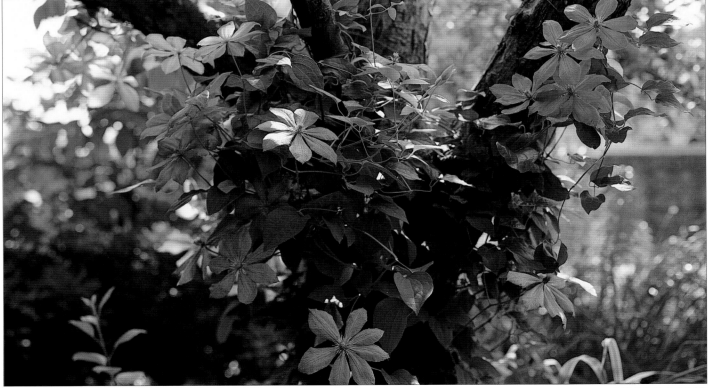

Pictured right: Look for the elements with "character" such as this rusting arm of a garden bench, and capture the textures with your camera angle and the light. Kodak E100S, f8½ at 1/60th second.

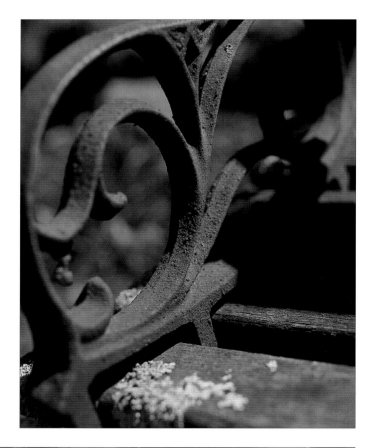

Pictured below: Light and color can create very interesting compositions such as the backlit yellowing leaves of this ginko tree with the autumn colors of a maple and the blue sky beyond. Kodak E100S, f11½ at 1/60th second.

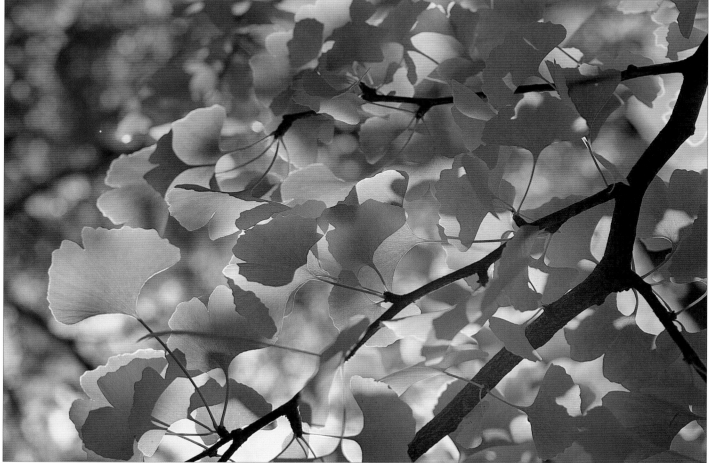

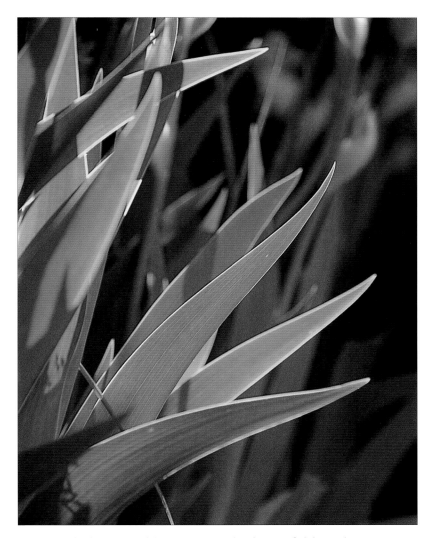

Pictured above: Iris blossoms can be beautiful but the morning sunlight dramatically backlighting this iris foliage created an image I could not pass up. Remember to look beyond the obvious to find the unique.
Kodak E100S, f8 at 1/30th second.

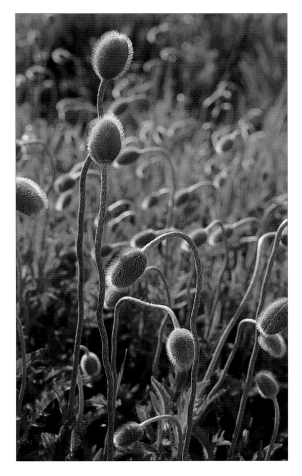

Pictured right: These oriental poppy buds take on an almost surreal look as they "dance" in this backlit morning garden. It's easy to overlook flowers before they bloom, but often they present very compelling images if you train yourself to see them.
Kodak E100S, f8½ at 1/60th second.

TEXTURES UP ABOVE

Gardens are filled with textures, many of which are up above. Always take the time to look up. Whether it is in the Spring with tiny buds or blossoms on the trees, in the Summer with abundant green leaves, or in the Fall with the multi-colored foliage, you are sure to find an interesting subject.

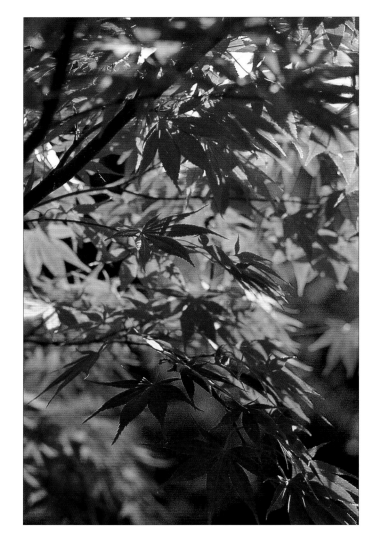

Pictured top right and bottom right:
Autumn leaves are an irresistible subject for most photographers. Although the wide view of brilliantly colored trees can be beautiful, I always like to look closer to see the light shining through the foliage as in these two images.
Kodak E100S, f11½ at 1/60th second

Pictured on opposite page:
The mass of green leaves with sunlight streaming through created many levels of texture which caught my eye. Normally, it is not a good idea to have the sun within the frame as it will overwhelm the exposure. In this case, though, I positioned the camera so that most of the sun was behind a branch and clump of leaves. This still allowed the brightness through and the effect enhances the feeling of standing in the shade of the trees on a sunny day.
Kodak E100S, f8½ at 1/30th second

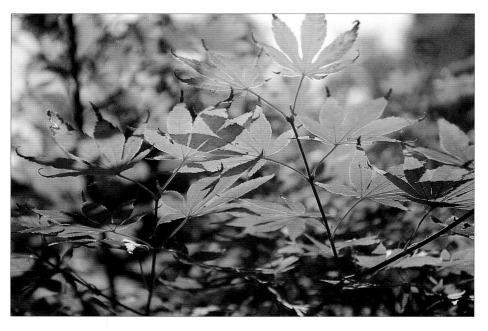

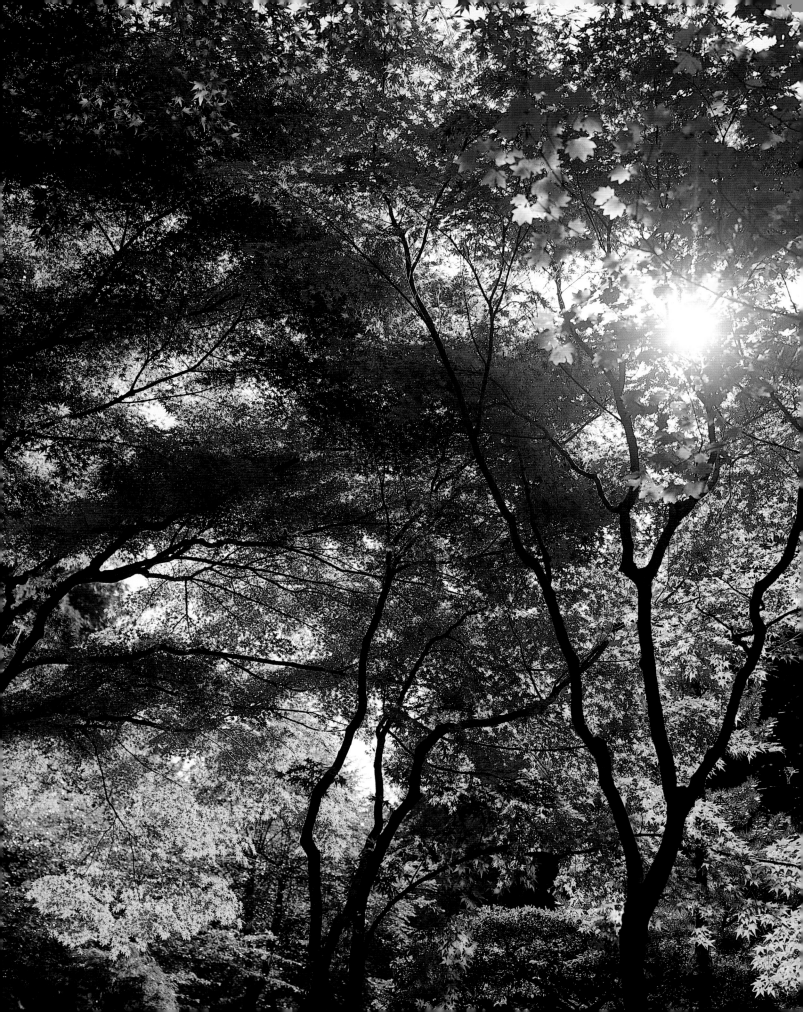

TEXTURES UNDER FOOT

Among my favorite textures in the garden are mosses, especially in the spring when they have the fresh green from winter rains. Though this picture appears to be some mountainous landscape, it is actually a very close view of a granite rock wall. The afternoon light caught the fragile filaments of the moss and also provided interesting texture to the uneven rock surface.

Pictured on opposite page:
Mosses on Granite Rock Wall
Kodak E100S, f5.6½ at
1/30th second

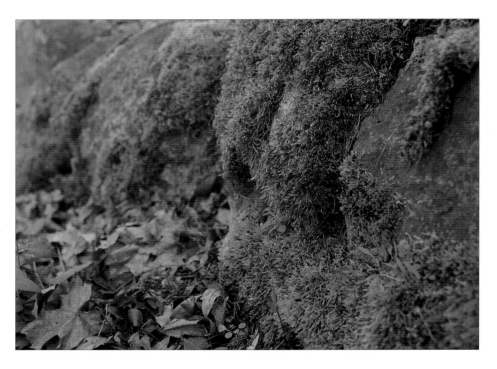

Pictured top right: Again, rocks and moss predominate in this composition. By including the leaf-covered ground, there is a sense of scale. The patches of bright green moss contrasting against the cool gray of the rocks lends an interesting design to draw the eye back into the photo.
Kodak E100S, f8½ at
1/30th second

Pictured bottom right: I found the shadow patterns across the rocks and moss of this patio to be a wonderful abstract shot. The hard angled lines combined with the rounded and textural rocks create an interesting composition. A shallow, selective focus was used to help emphasize the depth of the image.
Kodak E100S, f5.6 at 1/60th second

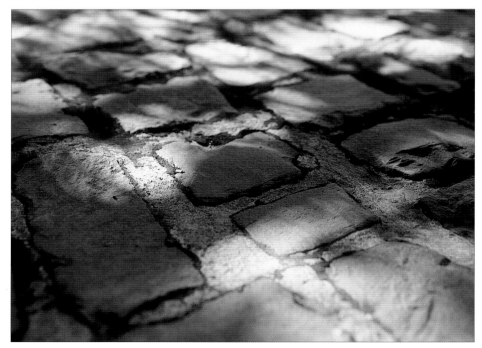

COMPOSITION 45

SNOW AND ICE

With the red gazing globe being almost exactly in the center of the otherwise gray and white image, I have broken one of the rules of good composition that says the primary subject should never be centered in the frame. In this case, though, I think it works because it emphasizes that the globe sits in the middle of a big, snowy landscape. Also, the horizon line of the snow where it meets the shrub branches sits low in the frame so the background composition is strong. The lesson here is probably to follow the rules unless you find something that works better.

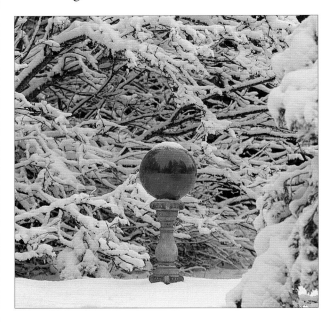

Pictured top left: Red Gazing Globe in the Snow
Kodak E100S, f11½ at 1/30th second

Pictured bottom left: The first crocus of spring and the last powdery snow of winter sometimes combine to make for some unique photographs. The low morning light gave the blossoms a beautifully luminous quality and the shadows in front made for a great abstract contrast to those blooms.
Kodak E100S, f8½ at 1/30th second

Pictured bottom right: The ice covering these delicate pear blossoms amazed me, sparkling in the early morning light. Being out in the garden early is often the key to finding some of the most striking images.
Kodak EKTACHROME 100, f8 at 1/30th second

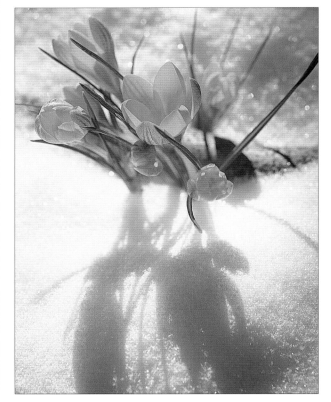

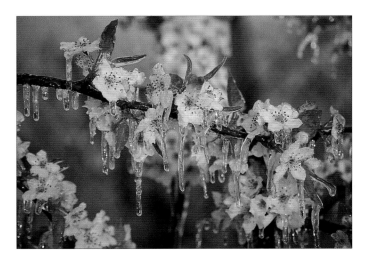

If I were to take only one photograph to epitomize this garden, it would have to be the chair on the dock. It conveys the wonderful peaceful feeling of that place. The chair is near the center of the composition, but offset just enough that with the similar color of the pampas grass behind, it works well. The round ripples on the water draw the eye right into the image.

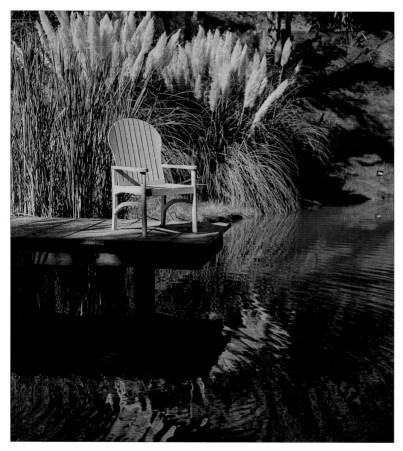

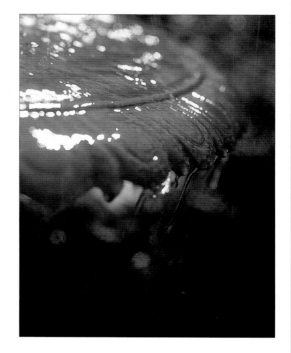

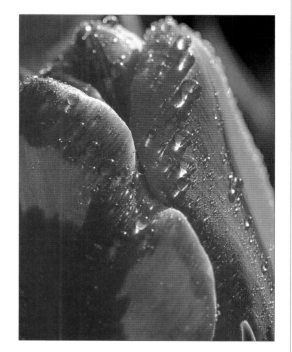

Pictured top left: Chair on the Dock
Kodak EPP, f11½ at 1/60th second

Pictured top right: Water is always a bit of a challenge to photograph well. In order to be visible, it needs highlights, which result from a light source behind it and also a dark background. In this stylized shot of a garden fountain, I tilted the camera to the right and used a very shallow focus so that the image becomes more of a quick impression rather than a complete record of the subject.
Kodak E100S, f8 at 1/30th second

Pictured bottom right: Droplets of water in the garden fascinate me. They catch the light like tiny jewels, creating wonderful sparkles. Here again, the light is coming from behind my subject so as it enters the water drops, it is refracted, creating bright points of light as it passes through.
Kodak E100S, f11 at 1/15th second

FRAMING AND CROPPING

The basics of composition lie in the way the image is framed – that is, what is included within the borders of the photograph. Small changes in how your subject is framed can make a big difference in the photo's impact. Unnecessary and distracting elements will take away from the main subject.

Framing With Your Image

Framing can be done entirely with the camera. Move your camera around while looking through the viewfinder. Move forward and backward as well as side to side and up or down. Once you have found the interesting view, that's your framing. Sometimes, however, you may decide to shoot a wider view to gain more depth of focus, which we'll look at a little later in the book.

Cropping With The Camera

The series of photos at bottom of this page and opposite page show the effects of various cropping done with the camera on the image of tulips growing in a field in Holland. The photo on the left, a wide view, creates a feeling of the vastness of the field with the lines of the planted rows going off to the horizon. The next photo, though similar in angle, focuses primarily on one row and yet still includes the horizon to give the shot context. The third picture, with the horizon cropped out, comes in much closer; it is then about the mass of color rather than the field. Finally, in the last two photos, I have first cropped the shot to give a feel for the individual plants and then reduced it to just the blooms. Each of these versions is a fine photograph in itself, but as you can see, changing the crop evokes an entirely different feeling.
All with Kodak Ektachrome 100, at 1/60th second

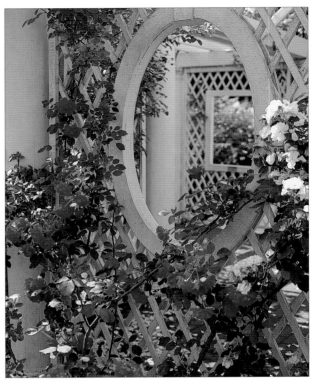

Pictured above: Here, the red and white climbing roses frame a portal in the lattice pavilion of the Cranford Rose Garden in the Brooklyn Botanic Garden. The portal itself frames the interior space and another window on the other side to create depth and interest. I purposely set the portal slightly to the right and high in the frame to avoid a symmetrical image that would have been too stiff looking. Rather, it has now become a more casual view.

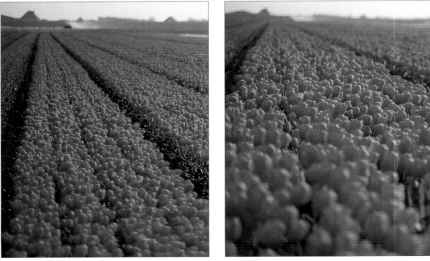

f11½ f11½

Cropping A Print

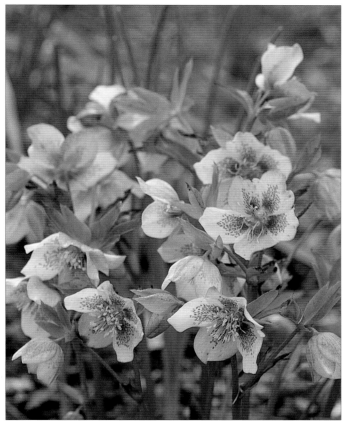

This shot below of hellebores looks good and does show the growth habit of the plant but the blooms are floating in a sea of brown garden soil. By having the image cropped when printed, as shown left, the blooms become much more prominent and it is a far more interesting photograph.

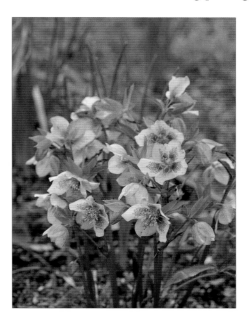

Kodak E100S, f5.6½ at 1/60th second

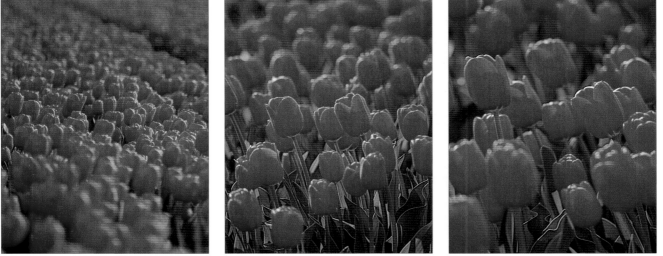

f11

f8

f8

A close view of this lavender shows the details of the blooms and has a richness of color and light while the wider view below emphasizes the growth habit of the plant.

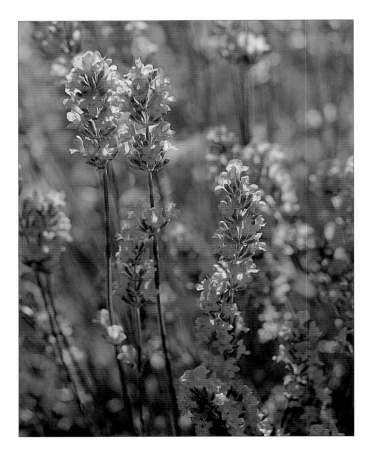

Pictured right: Lavender Close-up
Kodak E100S, f5.6 at 1/60th second

Pictured below: Lavender Wide View
Kodak E100S, f11 at 1/60th second

Pictured opposite: This very close view of a rose, so tight it cuts off the edges of the bloom, speaks to the impact of the color with its subtle variation from the edges of the petals toward the center. The larger-than-life view brings you in so close it's actually what you might see if you were bending over to smell the fragrance.
Kodak E100S, f8 at 1/30th second

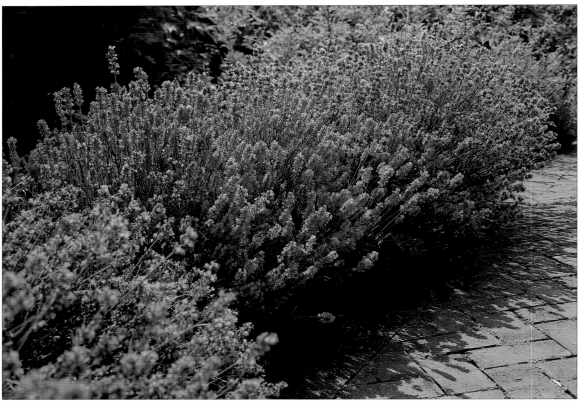

COMPOSITION 51

Pictured this page, top & bottom: This view of a garden gate in Italy is nice, but the dark walls to the side and arbor above overwhelm it. What I really liked was the ironwork of the gate. By coming in closer and keeping the gate in sharp focus, yet silhouetted, with the plantings in soft focus, I have changed the entire look. It's almost abstract but you still understand what you are seeing.
Pictured right: Kodak E100S, f8 at 1/60th second
Pictured below: Kodak E100S, f11 at 160th second

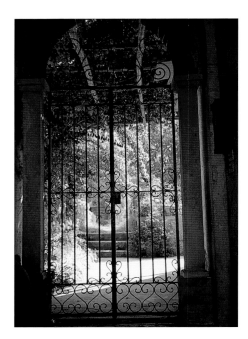

Pictured opposite page, top: The ironwork on this very old garden gazebo caught my eye, but when I looked closer, the wonderful relief molded into the concrete with its rich rusty staining was the more interesting picture. By having the curve arc gracefully from upper left to lower right, and showing just a bit of iron work, I have created a very pleasing composition.

Pictured opposite page, below: Although this Italian terracotta pot caught my eye, showing it all with the distracting brick wall breaking the background in half made for a very dull composition. Coming in closer to show only a portion of the planter and using the darker brick as a contrast for the geranium foliage says so much more than the wider view.

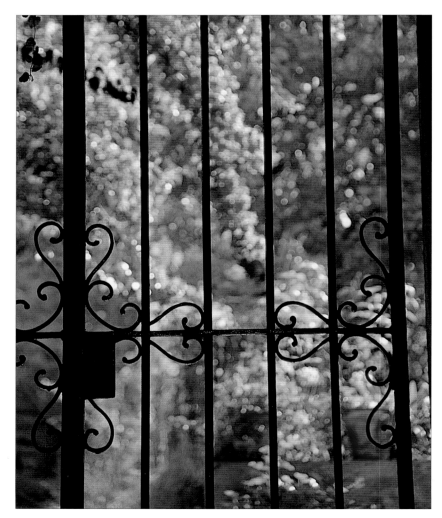

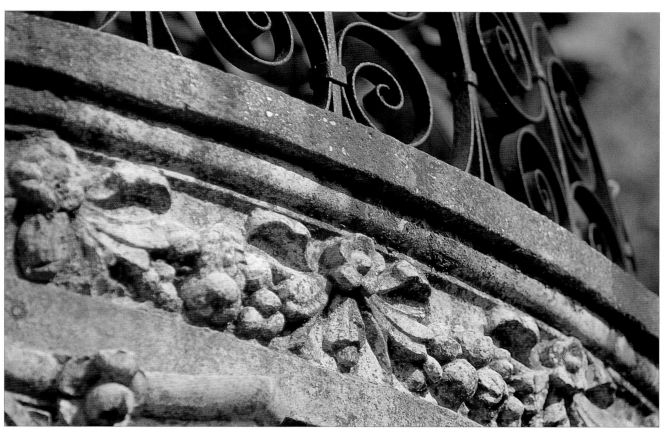

Kodak E100S, f16 at 1/60th second

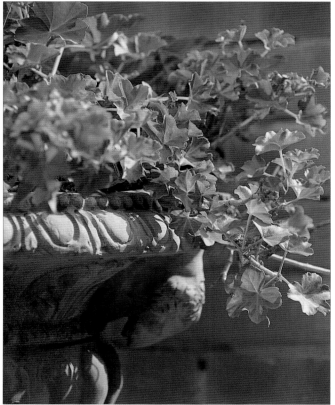

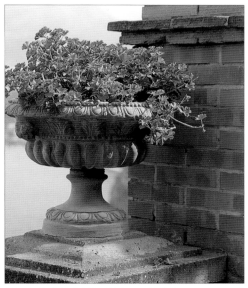

Kodak E100S, f11 at 1/60th second

Kodak E100S, f8 at 1/60th second

Muscari, or blue grape hyacinths as they are commonly called, have an amazing color that screams to be photographed. However, they are such a small plant it is often hard to give them a unique look. Purposely omitting the horizon or any other size reference and using a shallow focus to drive the composition allows the brilliant color to speak for itself.
Kodak E100S, f5.6 at 1/30th second

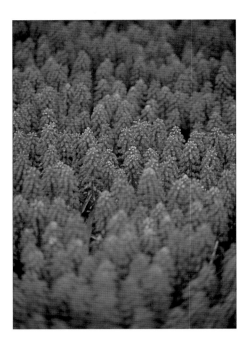

Pictured opposite: The very old wisteria growing in front of this wonderfully colored wall was striking, but I found the abstract shapes of the branches even more eye-catching. The late afternoon light casting long shadows and adding to the texture in the image made it irresistible to me. This is a perfect example of learning to crop with your eyes. Look beyond the obvious and you may find something even better.
Kodak E100S, f11 at 1/60th second

This ivy-covered wall is, like the grape hyacinths, all about color. However, an image of just the reds and greens was rather monotonous. With the addition of the contrasting blue shutters of the window, it sparkled. To create interest, I placed the window in the extreme upper right and kept it small in the frame to emphasize that it was high on the wall above me.
Kodak E100S, f11½ at 1/60th second

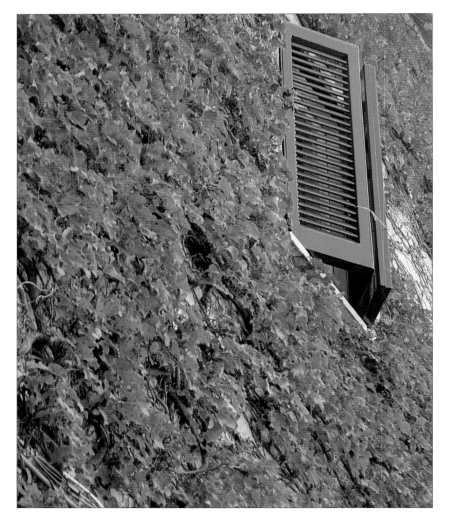

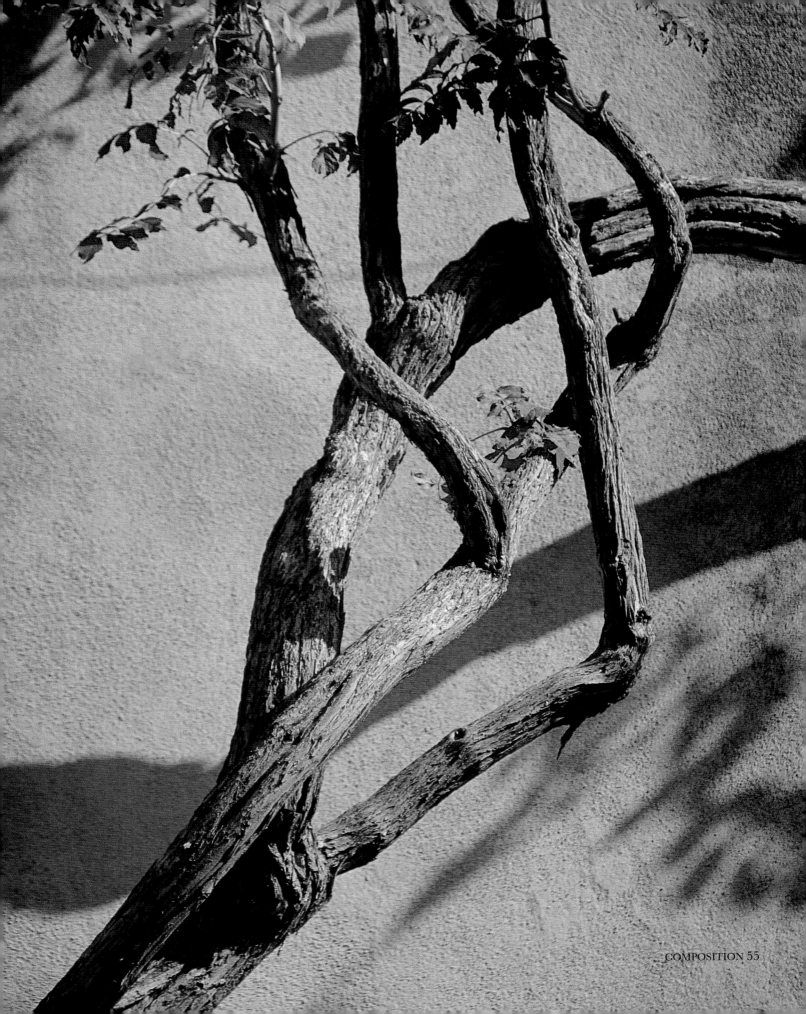

VERTICAL OR HORIZONTAL?

Making the choice between a vertical or horizontal format for a photograph can have an influence on the overall feel of the image. Both of these photographs of a field of lavender are effective, but the format definitely changes how we see the subject. The horizontal or landscape view, as it is often known, gives the impression of the broad expanse of the field.

The vertical or portrait view emphasizes the length of the rows with their shadows reaching off to the horizon.

Always carefully consider what it is you wish to convey with your photos and select the format based on that decision.

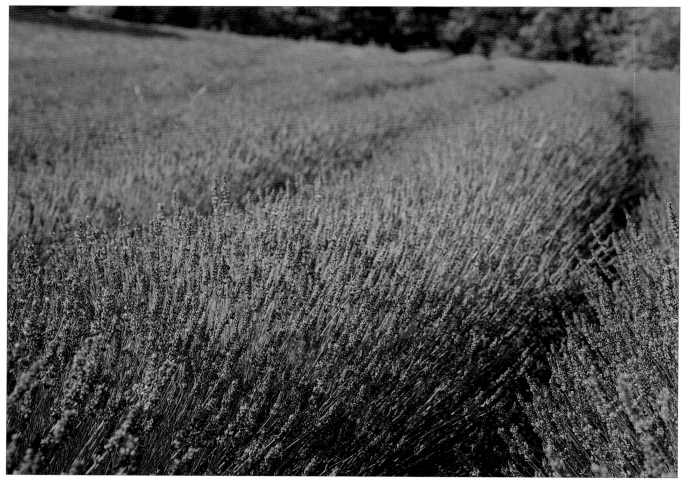

Both photos: Kodak E100S, f11½ at 1/60th second

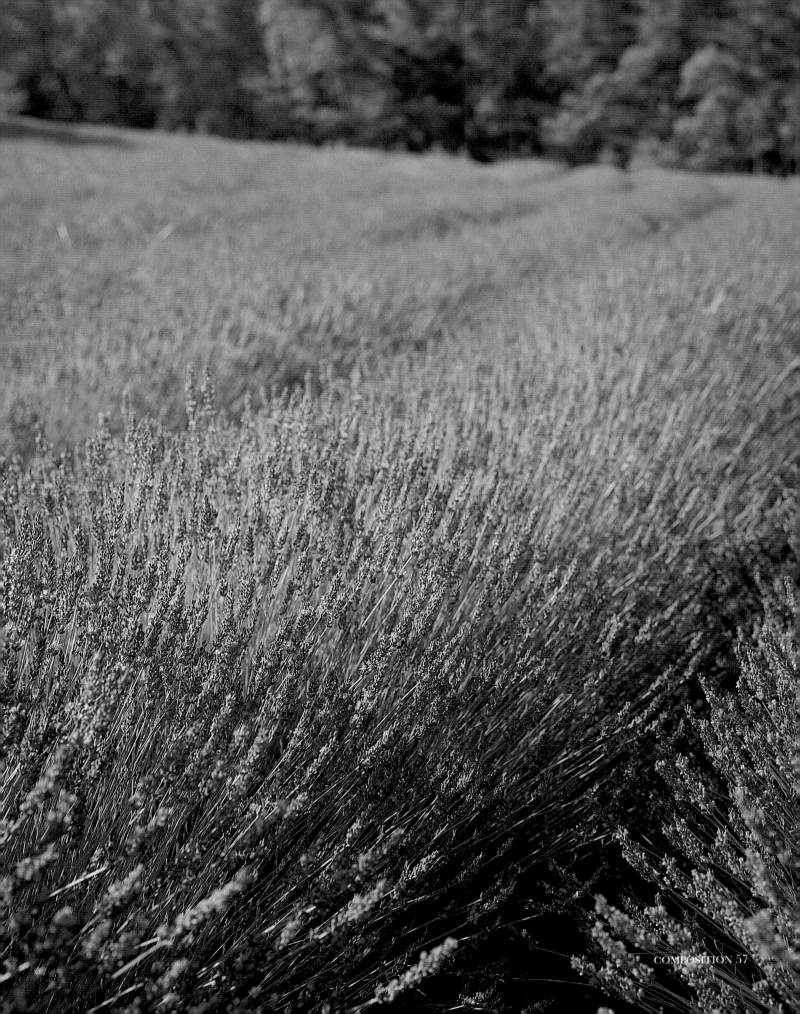

COMPOSITION 57

SUBJECT PLACEMENT IN THE FRAME

Pictured right: Although these tulip blooms cover much of the frame, there is a fairly strong line where the color changes from predominantly red and white to dark green. By placing this line low in the image, I have emphasized the blooms and reduced the strength of the foliage.
Kodak E100S, f8 at 1/60th second

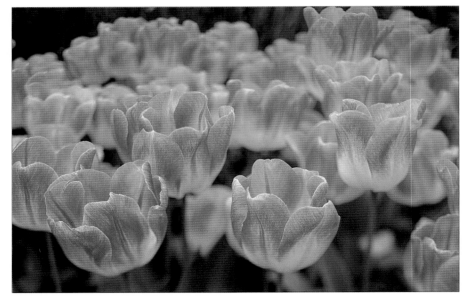

Pictured right: At first glance, it might appear this photo doesn't follow the rule of thirds. However, the largest blossom of the rose, which is in the foreground, is actually at one of the one-third line crossing points, with the other blooms flowing back into the composition.
Kodak E100S, f11 at 1/60th second

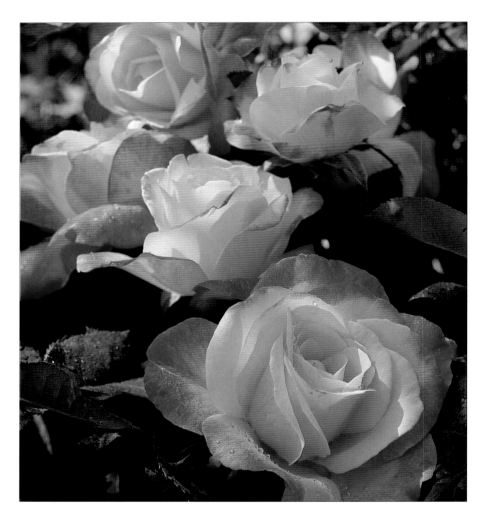

There is a good rule of thumb to follow when composing your shot. It is the "rule of thirds." If you draw imaginary lines vertically and horizontally through the image area as indicated in the illustration below, try to place your primary subject ideally near one of the crossing points of the lines (circled in the illustration). If there is a strong vertical or horizontal division in the image, it should fall near one of the top, bottom, left or right lines. Keeping this technique in mind will help you avoid symmetrical compositions that can look very stiff and unnatural. However, strict adherence to these rules is not always necessary. Though most of my photographs in this book follow the guidelines, you will see exceptions. My advice is to experiment. Depending upon the subject, not using the rule of thirds may work perfectly well.

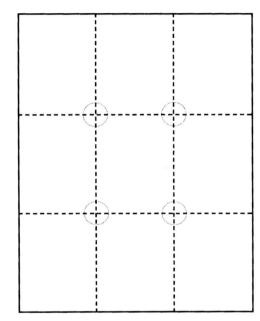

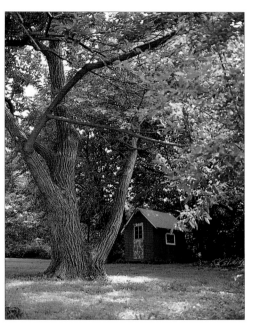

Pictured above: This photo uses the rule of thirds in three ways. First, the garden shed is located at one of the one-third cross points. Second, the line of grassy lawn is approximately one third from the bottom of the photo. Finally, the main trunk of the tree is about one-third from the left side.
Kodak E100S, f11 at 1/60th second

Pictured right: The hellebore photo here uses the rule of thirds in a different way. Although there is no single straight division line, the plant covers about two-thirds of the total image area with the background covering one third by combining two triangular shapes.
Kodak E100S, f8 at 1/30th second

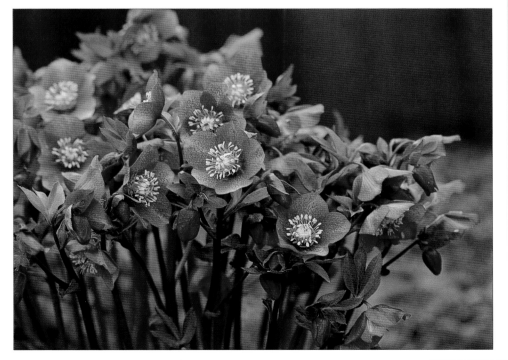

DIRECTING THE EYE

Another important element of composition is directing the eye into and around the image. You always want to capture the viewer with a center of interest that is well placed, but beyond that you must keep your viewer within the image with good eye-flow. You want to lead the eye from the main subject into the rest of the picture and within the image rather than directing it out the side.

This direction of the eye can be done with lines, elements, light, and contrast. It can also be done with focus and depth of field, which will be discussed more in the next section.

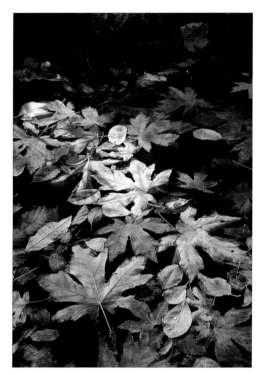

Pictured top right: The leaves in this photograph cover almost the entire area fairly evenly and, by themselves, would not have a strong directional flow. However, the sunlight crossing on an angle through the frame leads the eye toward the top, or into the shot. The shadowy areas at the top and right draw the eye back down to the front. Together, the light and dark areas create an almost circular eye-flow.
Kodak E100S, f8 at 1/60th second

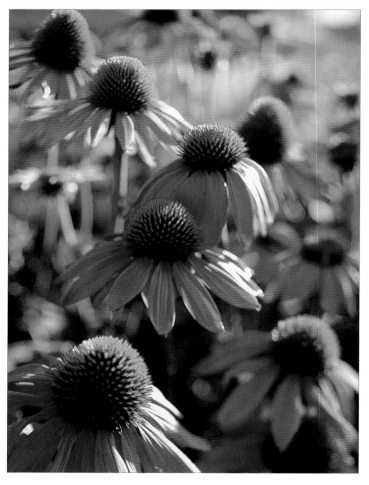

Pictured bottom right: In this image, it is the strong individual elements of the Echinacea blooms stepping backward that bring the eye into the composition. And, although they lead strongly toward the upper corner, the additional, softer focused blooms in the background keep you within the frame and back to the front.
Kodak E100S, f11 at 1/60th second

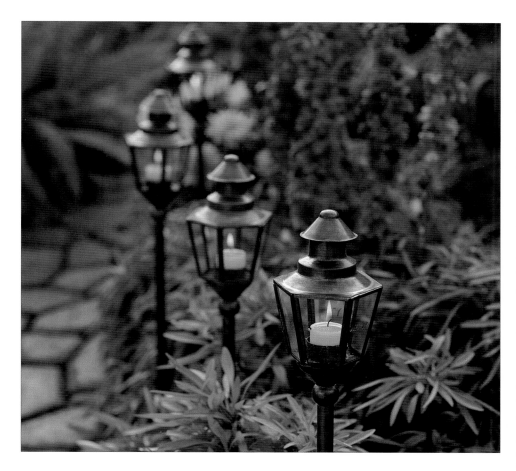

Pictured at left: The garden lamps in this evening shot curve gracefully back into the photo. Their curve is echoed by the walkway. The dark plant in the upper left keeps the eye within the composition and the strong vertical of the delphiniums draws attention back down toward the front. The very soft focus at the back of the image emphasizes the depth, which also helps to enhance the composition. Kodak LPP, f8 at 1/15th second

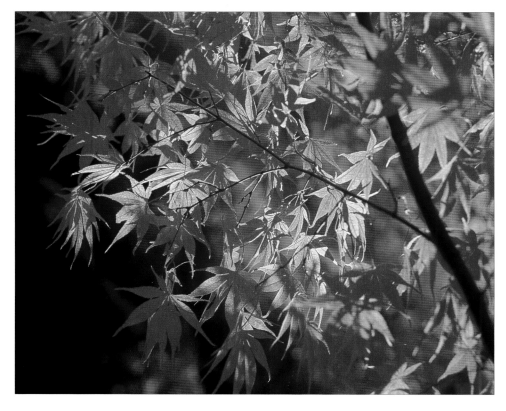

Pictured below left: This shot of autumn leaves still on the tree uses a strong line as well as a strong contrast of light and dark to direct the eye. The branch at right, because of its darkness in the bright leaves, catches the eye first and pulls it upward. By going behind the foliage before it leaves the frame, the eye is pulled left to the area of great contrast between the orange leaves and the very dark background. The curve of this contrast line pulls back down to the right, finishing the round eye-flow. If the strong, dark branch at right had gone completely to the top edge of the frame, the composition would have been severely compromised by allowing the eye to move straight out the top of the image. Kodak E100S, f11 at 1/60th second

DEPTH OF FIELD

The depth of field is, in very simple terms, how much of a photograph is in sharp focus – that is, at what distance from the lens the sharp focus begins and how deep it continues before the area behind the subject goes out of focus.

The most important control in determining depth of field is the size of the aperture. The smaller the aperture, the greater the zone of sharp focus and, therefore, the larger the aperture, the more shallow the zone of focus. So, for example, an aperture of f22 will, if everything else is equal, provide a greater depth of field than an aperture of f8.

In combination with the aperture size, distance from the lens to the subject will also affect how deep the sharply focused area will be. Generally, the closer you are to the subject, the more shallow the depth of field. As you move back from the subject, the depth of field increases. If, for example, you were ten feet from your subject with an aperture setting of f8, you might have a depth of field of around six or seven feet. If, however, you used the same f8 aperture setting but were only two feet from your subject, the depth of field may be only six inches or less. You will find that in garden photography, with very short distances to the subject, you are often working with a very shallow depth of field-maybe only a few inches down to a fraction of an inch. Focusing becomes very critical and you must decide what part of your subject to keep sharp. This is known as selective focus.

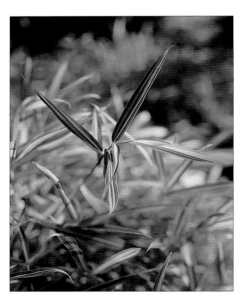

Reducing the aperture will increase the depth of field but, as discussed in an earlier section, a slower shutter speed will be required for the same exposure. This can be a difficult or impossible tradeoff when shooting outdoors unless the air is very still to prevent subject movement.

The focal length of the lens being used also will affect the depth of field you can achieve. Lenses of shorter focal length, say 28mm, will give a greater depth of field at f11 than a lens with a focal length of 100mm.

The entire issue of depth of field can be rather confusing and really takes experience to fully understand it. Experiment by setting up your camera on a tripod three feet from a flower bloom. Shoot six to eight photographs of that flower, starting with a very wide open aperture and step it down one stop for each successive frame. Be sure to adjust the shutter speed accordingly. For a second series, keep the aperture at the same setting, but start shooting at the closest focus distance you can with the lens you are using. Then, with each frame, move the tripod backward in even distances, around twelve inches, always making sure you are focused on the subject. Make careful notes of the aperture and/or distance from the subject used for each frame. When you have the film processed, compare each photo with your notes of the camera setting. This will help you understand how various adjustments can make a difference in the depth of field.

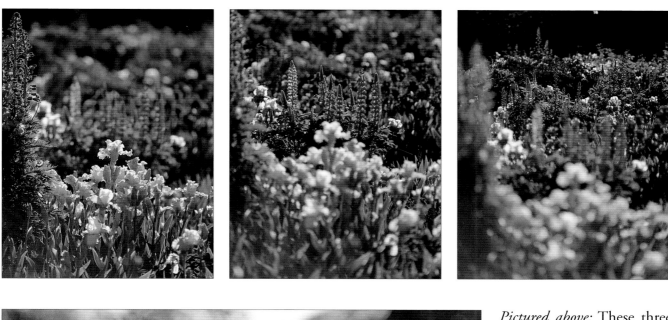

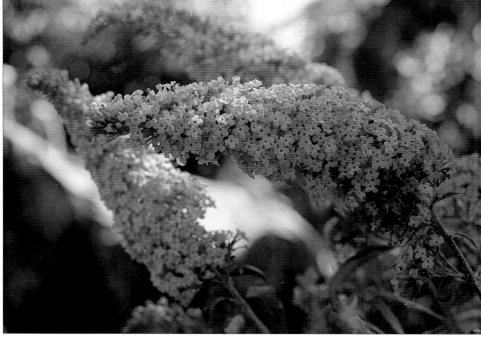

Pictured above: In this image of pink buddleia, I chose to have a depth of field that brings only the front blooms into focus. The background here was very uninteresting and distracting. By making it soft, it still gives the feel of the garden foliage back there but it does not detract from my center of interest. Kodak E100S, f8 at 1/60th second

Pictured opposite: I found the texture and color of these grasses very interesting. However, if I had shot them with a greater depth of field, everything would have been in focus and the shot would be far too busy. With the very shallow depth of field, the foliage in the front stands out. It creates contrast by focus, rather than light.
Kodak E100S, f8 at 1/60th second

Pictured above: These three photographs illustrate how the area of focus can be varied for differing effects. The first image is focused on the iris blooms near the foreground, making the middle ground and background soft and blurry. The second shot places the focus midway back into the garden, using soft focus in the front and back to create levels of depth. The third photo takes the focus into the background, leaving everything from the middle ground to the foreground in soft focus. This tends to take the eye straight to the background, creating a great deal of depth to the image.
All subjects:
Kodak E100S, f8 at 1/60th second

These ornamental grass seed heads had a very casual look and catching that feel on film called for a shallow depth of field. By allowing only the front-most head to remain sharp and letting the rest fall out of focus, I created a softness to match the impression I first had upon seeing them. Kodak E100S, f11 at 1/60th second

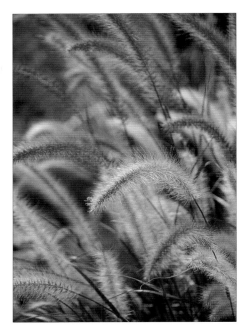

Pictured below: Capturing butterflies can be a matter of luck and patience, but beyond that, it requires simplicity. They are visually so delicate that it is important not to have too many distractions to draw the eye. Here, I chose a depth of field to let the back of the flower and, especially, the background to go out of focus while keeping the body of the butterfly as well as the center of the Echinacea flower in focus. Kodak E100S, f5.6½ at 1/125th second

Pictured opposite: I wanted to capture the impact of these rosehips and the frosty autumn look. Because they are rather unusual looking, it was important to capture enough of the foliage and the flower bud to identify the subject. Therefore, I chose a depth of field that held the important elements sharp but that also let the background go quickly soft so as not to distract. Kodak LPP, f8 at 1/60th second

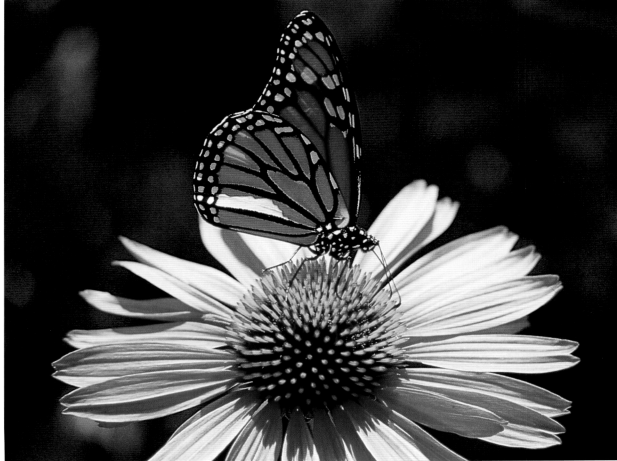

TAKING A DIFFERENT LOOK

When you are in the garden looking for subjects to photograph, try to go beyond the ordinary. Look at your subject from as many different angles as possible. You might just be surprised.

In photographing these tulips, I first shot them from a rather ordinary angle, the side. With the strong side light and contrasting background, it's certainly an effective photograph.

When I looked at these blooms from a high angle, the yellow centers became evident so I wanted to capture that look as well. Because I was relatively close to the blooms, to make them large in the frame, my depth of field was fairly shallow. I had to

make a choice of what to keep in focus. Since the real interest seemed to be the yellow color and contrasting pollen, I decided the pistil and stamens should hold the sharp focus.

My favorite angle, though, was from directly above the blooms looking straight down. Because they look so unusual, it's hard to identify them as tulips at first look, but that is what drew me in. It is the almost abstract appearance of the blooms that creates the interest. I was very close to the subject, which allowed me only a very shallow depth of field – little more than 1/4". Again, I chose to focus on the pistil and stamens, letting their star-like shape become the real center of interest.

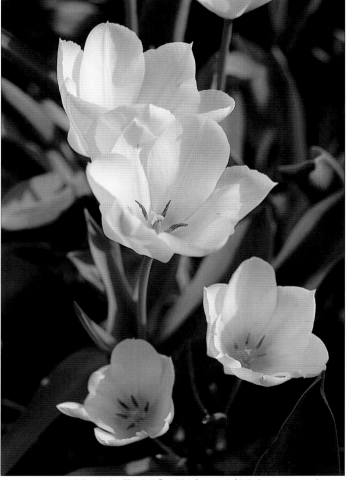

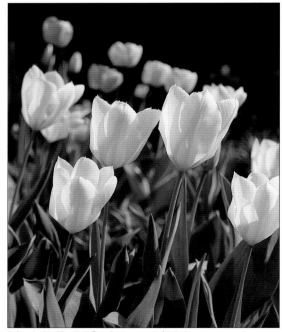

Kodak E100S, f11 at 1/60th second

Pictured right: Kodak E100S, f8½ at 1/60th second
Pictured opposite: Kodak E100S, f8 at 1/60th second

COMPOSITION 67

IT'S NOT JUST FLOWERS

Flowers certainly are the stars of most garden photography, but don't limit yourself. Vegetable gardens and fruit trees also offer wonderful opportunities for beautiful photographs. Is there anything more tempting than a bright red juicy tomato hanging on the vine, beckoning to be picked? Capturing that emotion on film will make your photos irresistible.

Pictured right: Tomatoes have wonderful color while the stems and leaves have interesting textures with their shapes and fuzzy surfaces. To give a look of freshness to the tomatoes, I gave them a spritz of water as I often do with flowers I photograph.
Kodak E100S, f11 at 1/60th second

Pictured below: The bounty of harvested fruits, as with these pears and apples spilling out of the bucket, make very nice images. Letting the bright light stream through the window added highlights to the softer room lights. Again, the water on the fruit adds an even greater sense of freshness.
Kodak LPP, f16 at 1/30th second

Pictured opposite: I was unable to resist the dappled sunlight on these two perfect pears. The fresh light right after a passing summer rain shower is almost perfect. My composition places the fruit virtually in the center of the shot, usually not desirable, but the leaves and dark branch at the top help to offset them along with the very soft focus of the background below the pears.
Kodak E100S, f8 at
1/60th second

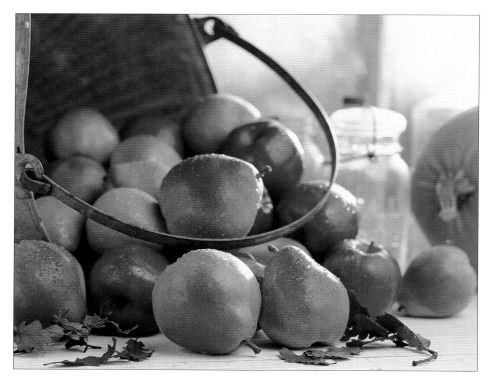

COMPOSITION 69

A SURPRISING SUBJECT

Asparagus might not be the most glamorous thing to photograph in the garden. But if you apply the techniques discussed and look for what is interesting in a subject, even asparagus can make a good garden image.

Pictured right: Asparagus growing out of the ground are rather odd other-worldly looking plants. While shooting them straight on might make a good record of their growth habit, it would not make a very interesting image. I decided to go up above and look down. This allowed me to create a dynamic photo. The shallow depth of field emphasizes the height of the stalks and also puts the dirt, an uninteresting element, completely out of focus.
Kodak E100S, f5.6 at 1/30th second

Pictured below: I loved the bright green of these asparagus spears, freshly cut and ready to go into the kitchen. Even though we see only a small part of the kettle, it becomes a strong anchor in the composition that would otherwise be weak with the very directional angle of the stems pointing out the top of the frame.
Kodak E100S, f8 at 1/30th second

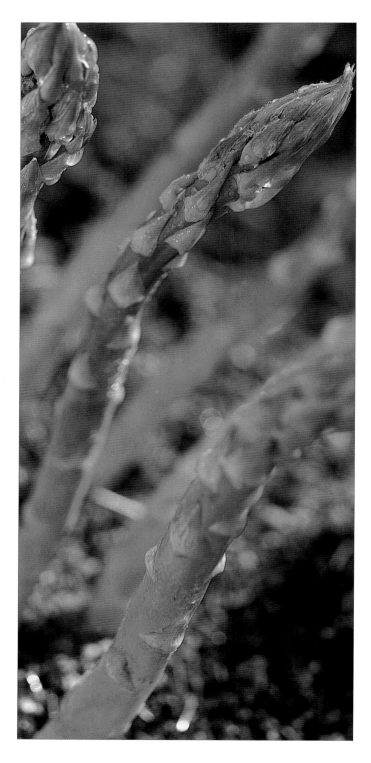

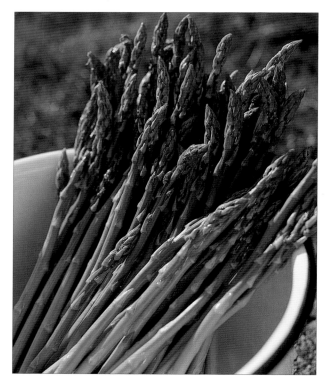

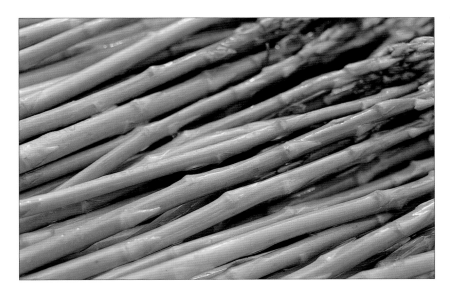

The very unusual appearance of asparagus also makes a wonderful study of its textures. Each of these two shots isolates sections of the spears and looks at each in isolation. The smooth, wet stems look like a bamboo screen. The texture and variation of color in the tips, along with the strong cross light, makes for a striking composition.
Both: Kodak E100S, f5.6 at 1/30th second

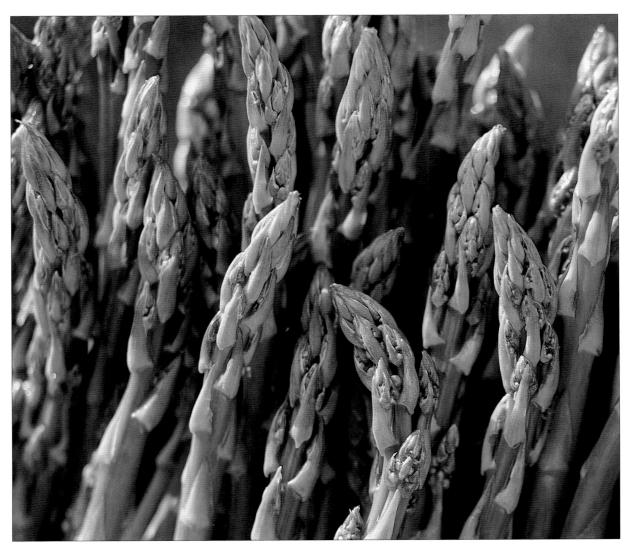

THINK ABOUT COLORS

A good composition is made up of many elements as we have seen, but one that is important and often overlooked, is color. Contrasting colors help separate various parts of the composition and can lead the eye through it. Colors that stay within a limited range can lend a sense of continuity.

Pictured opposite page: The roses at left stand out against the wood surface, basket, and terracotta pots with which they have been shot, but the colors of all the elements are also quite unified and create a pleasing look. The warmth of the background works well with the warm colors of the blooms. The brightest light is falling across the blossoms to help them to contrast well without being garish. Kodak EPP, f16 at 1/60th second

Pictured left: This photo of mixed perennials has a very limited color palette of lavenders, greens, and tiny touches of yellow to highlight. It is very striking because it is so limited within a mostly cool color range. It allows each of the elements in turn to capture the eye. Had there been additional colors, they probably would have detracted from the overall appeal and would have made for a less interesting composition. Fuji Velvia, f 11 at 1/30th second

Pictured below: One of the most challenging colors in garden photography is, oddly enough, green. It often tends to go very dark, almost black. This photo of the wonderful old tree surrounded by hostas, ivy, and other mixed foliage is one of my favorites because it contains almost exclusively green. The reason it is a successful picture is the bright afternoon light that falls across the various textures to build contrast without leaving heavy, dark shadows. Fuji Velvia, f11$\frac{1}{2}$ at 1/60th second

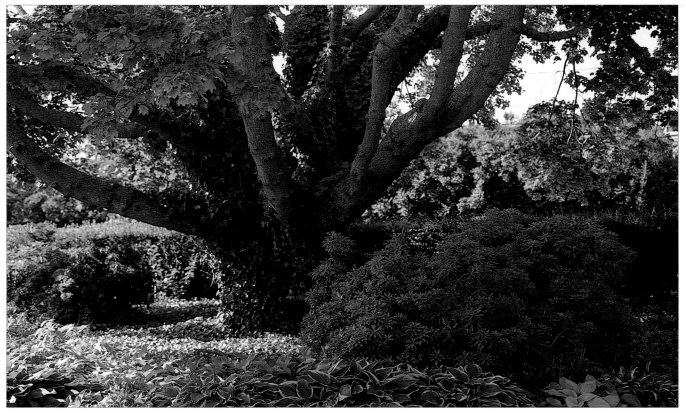

BRING IT ALL TOGETHER

Pictured below: The hydrangeas, with their limited color palette and very shallow depth of field, and the strong angular lines of the bench all make for a pleasing composition. Kodak EPP, f8 at 1/60th second

Pictured opposite page, top left: Although the wheelbarrow with lavender has a strong directional flow toward the corner of the photograph, the wheel serves to bring the eye back into the image and back up to the lavender. Kodak E100S, f8 at 1/125th second

Pictured opposite page, top right: This picture breaks one of the primary rules of composition that the subject should not be centered in the frame. However, the strong contrast of the bright highlight against the green background to the right is a strong visual draw and the very round bloom form carries the eye back around to the left. The tiny bits of soft focused blooms on the left also help to give a slight imbalance to the central subject. Kodak E100S, f5.6 at 1/125th second

Pictured opposite page, bottom left: Tiny twigs angling downward from the sides provide a strong visual movement in this shot. I would normally be hesitant of including the lowest twig, which could lead the eye out of the photo, but the bright red of the crabapples is strong enough to hold the composition together. Kodak E100S, f 11 at 1/60th second

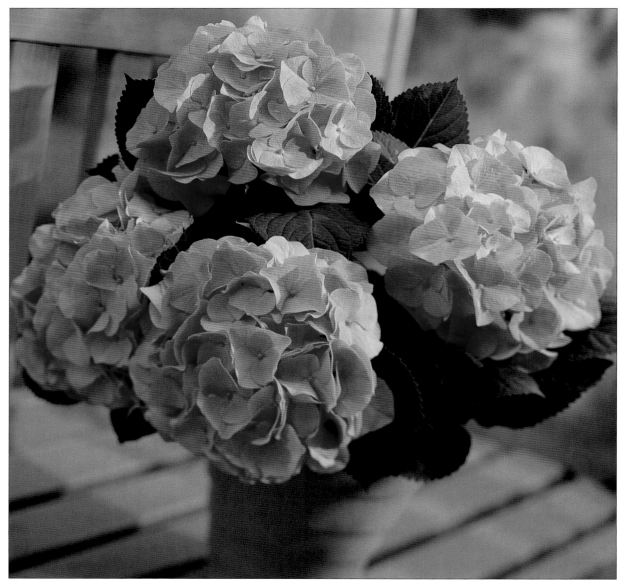

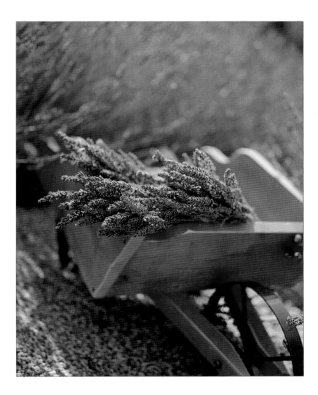

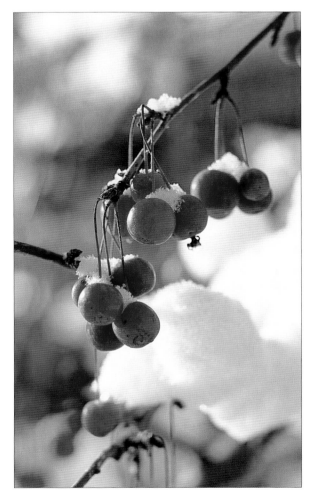

Pictured below: The sunflowers are relatively tiny in the photo, but because they are the only bit of bright color in an otherwise drab image, they become a strong center of interest. They have a good placement in the lower right area of the picture, making a very pleasing composition. Kodak E100S, f8½ at 1/60th second

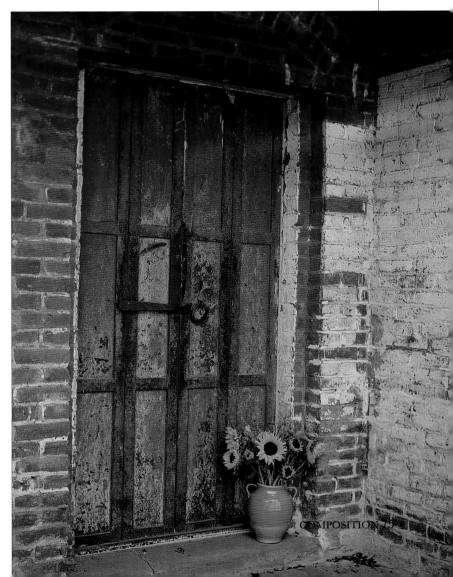

LIGHT

Along with composition, interesting light is one of the most important elements in creating a dynamic garden photograph. Good light will make an ordinary subject striking, while bad light will turn an extraordinary image into something quite dull. Whether light is good or bad does not depend upon its intensity. Good light and bad light are defined by how well it works with the subject. Bright, sparkling sunshine is sometimes best while hazy light or even a cool overcast can be equally effective, depending upon the feeling that you want to convey.

Although there are many instances where artificial light-flashes or strobe lights-may be used, I rarely work with them in the garden. They require skillful use to avoid an unnatural look. In the following pages I will concentrate only on the use of natural light and ways to modify it to make interesting photographs

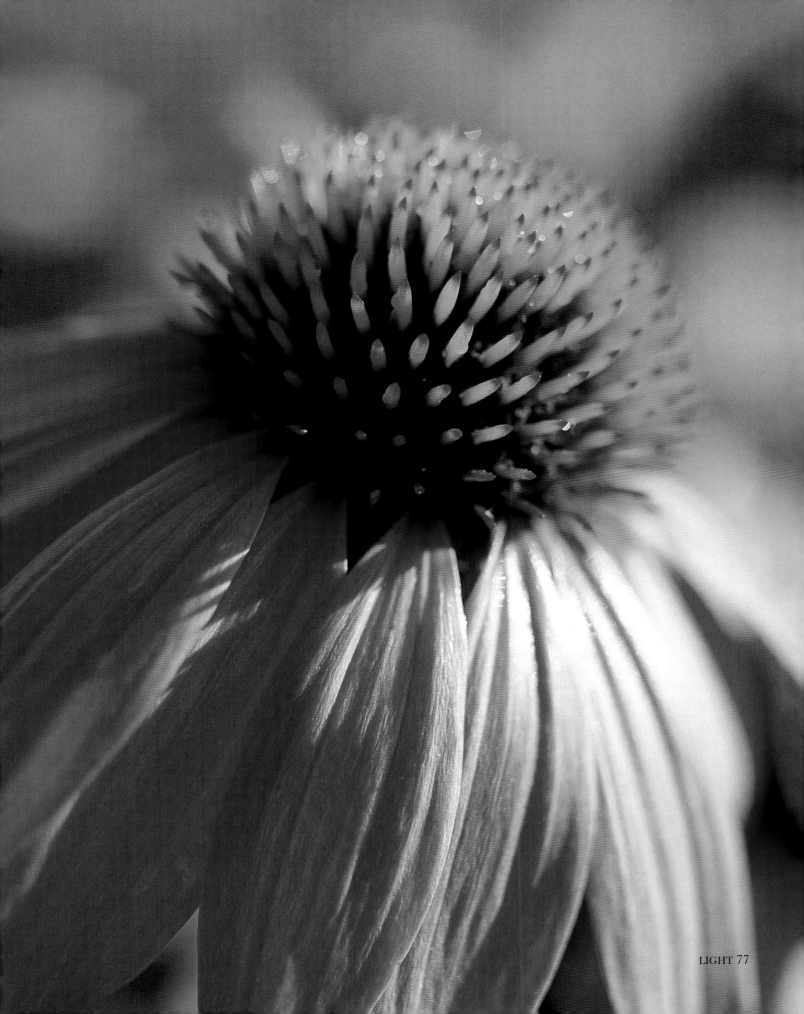

LIGHT 77

LIGHT MODIFICATION

There is a general rule that most photographers live by which says, "outdoor photography should be done before 10AM or after 3PM." This is to have a low angle of sunlight rather than the direct, overhead light in the middle of the day. While this is an excellent rule that I try to follow when possible, sometimes it just can't be done. In these cases, there are several techniques to use that will modify the light so that it looks more attractive. Even in the early or late part of the day, some of these methods will be of assistance.

Fill Cards

One light modification device I use in almost every situation, regardless of the time of day, is a fill card. Simply put, this is a device that is used to reflect light into the subject, filling the shadow areas with light. A fill card can be nothing more than a piece of white art board or foam core board or you can use commercial reflectors that can be folded down into a smaller space. Although the white fill card will be most useful, I also carry silver and gold reflectors. These are much brighter and reflect the light strongly so they are trickier to use. Also, the gold reflector will change the colors, producing a much warmer look that can be helpful when shooting in a shady area where the light is naturally more blue.

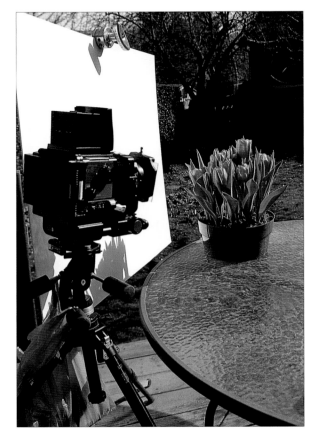

Fill cards should be placed generally on the side opposite the sun or main light source. Depending upon the strength of the sun, the card can be very near your subject or back several feet. Placement takes experience, but you should move the card around, both near and far, while observing the effect. You want the shadows to be brightened but not so much as to overwhelm the highlights, flattening the overall light. At first, you might want to try shots with differing amounts of reflected fill light to see how it looks on film.

Pictured above right: Here you see the white fill card placed to the side of the potted pink tulips that are in the larger shots below.
Kodak E100S, f11½ at 1/60th second

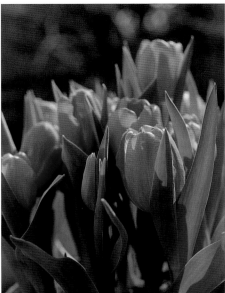
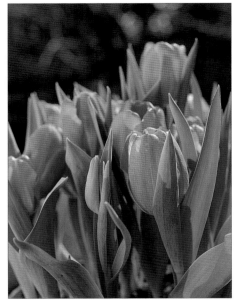

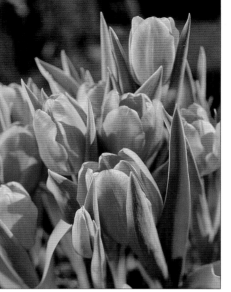 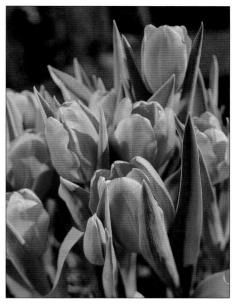

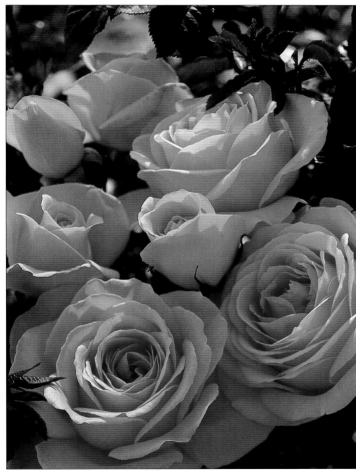

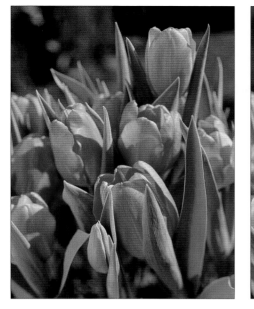

Pictured above: These three images show the effect of various fill cards on the same shot with the same light. On the left, a white card reflects the light. In the center, a silver reflector is used which is a much brighter and harsher fill. I rarely use silver reflectors in bright sunlight. They are best in shadier spots where the light is softer to fill in. On the right, I have used a gold reflector which, like the silver, is strong and must be used judiciously. You can also see that it gives a definite gold tone to the fill light and, in this case, is probably too strong. Again, the gold reflector is probably best used in shadier locations where a warming of the naturally cool light is more desirable.
All: Kodak E100S, f11½ at 1/60th second

Pictured left: These roses were shot with the sunlight coming from behind with little illumination on the front. In order to get an acceptable exposure, I placed a white fill card directly in front of the subject and right below the camera lens to reflect light into the blooms. Without the fill card, the contrast between the highlights and shadows would have been far too great.
Kodak E100S, f8½ at 1/60th second.

Pictured opposite page, bottom: The image on the left shows the tulips without the use of a fill card. The shadows are a bit dark and the photo seems a little too heavy. On the right is the same shot with a white fill card placed on the left side as shown above. It definitely helps soften the light and it is more pleasing to the eye.

DIFFUSING THE LIGHT

Often when shooting in bright sunlight, particularly in the direct mid-day sun, it is helpful to diffuse the light to soften it. Without diffusion, it can be harsh and unattractive. Diffusion with a sheer fabric, such as the type of material used in window coverings, will give an effect similar to what you see on days with thin, hazy clouds in the sky to soften the light and reduce the contrast.

The diffusion material I use is a piece of professional photographic equipment designed for the purpose. It has a metal frame holding the fabric and can be easily mounted in one of my stands. However, it is just as effective to use a sheer curtain fabric commonly available. Drape it over a stand or branch so that it is between the sun and your subject.

Experiment with placement of the diffuser. Generally, the closer it is to the subject, the more the light is diffused. Conversely, the further away it is, the less effect it has.

Pictured opposite page: These daffodils were shot at about noon with the sun very high in the sky. By using diffusion, they have a very soft appearance and look much more like they were shot in morning light.
Kodak E100S, f11½ at 1/60th second

Pictured above: Here, you can see my diffuser placed just above the tulips.

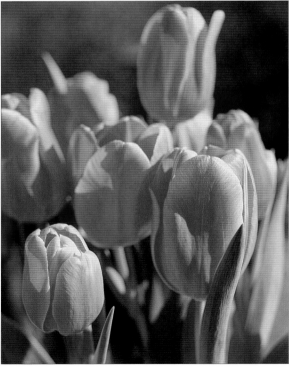

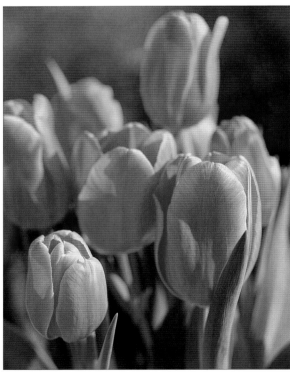

On the left, the tulips are photographed without any diffusion. The sun is very strong; it seems just a bit too harsh and doesn't help the subject. The shot on the right is the same group of tulips with the diffusion in place. The change is subtle, but you can see the light has been softened and has less contrast.
Kodak E100S, f11½ at 1/60th second

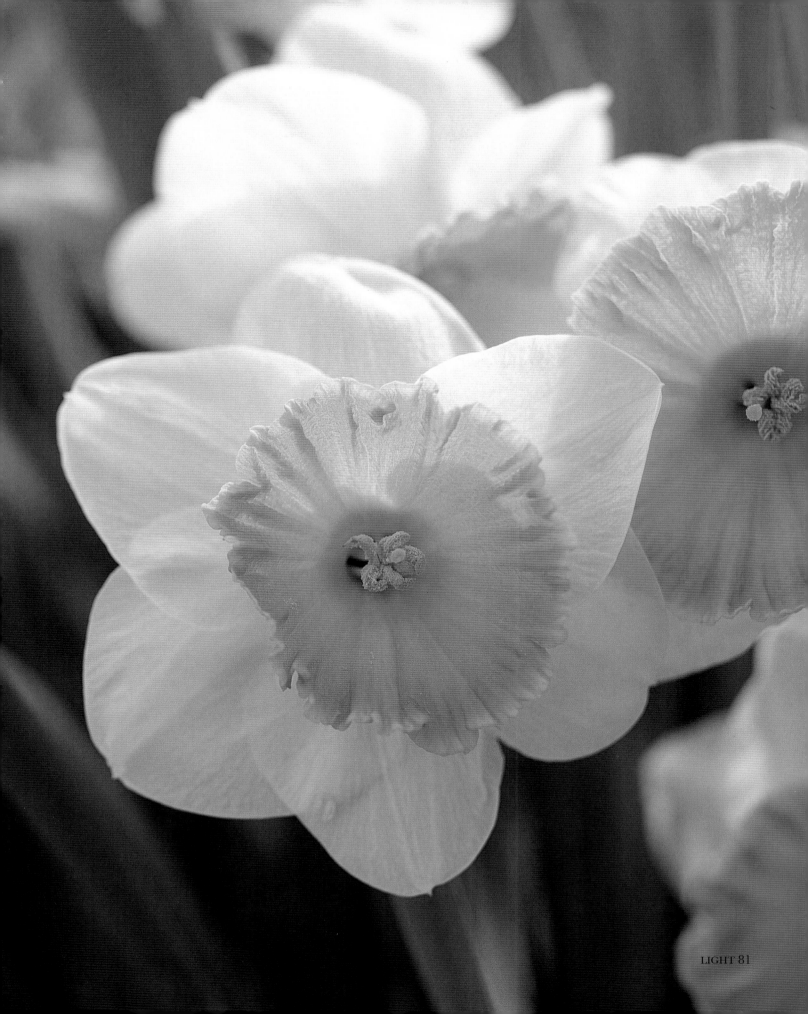

BREAKING UP THE LIGHT

Another technique to use for softening harsh light is to break it up with shadows to create the look of light coming through foliage. It is an excellent way to make mid-day light look much more pleasant.

This shadowing can be done with a piece of cardboard cut with random holes to simulate the light coming through leaves. This is known as a **cucoloris** or "cookie" for short. It is held above the subject to let the sun come through the holes. An easier way to create the shadows, and the one I prefer because it is far more natural, is to use either a small branch with leaves or even simpler, a bit of fake foliage which I always carry along as one of my "tools." When using a cookie or branch, experiment with the position. The closer it is to the subject, the more defined the shadows will be. The shadows will become softer and less pronounced as it is moved back. Also adjust the positioning so that the sunlight comes through in the places just where you want it.

Above: The small branch of artificial foliage is held just above the tulips.

Pictured opposite page: These roses were actually photographed in the middle of the day out in a rose-growing production field without a tree in sight. To say the light was bad is an understatement. However, with the dappled light created with some branches, the flowers take on a very pleasing appearance and it would never be suspected what the real growing situation was.

Kodak E100S, f11½ at 1/60th second

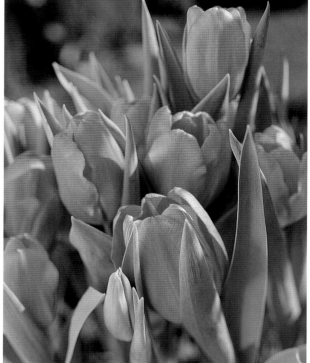

Above: The photo on the left shows the tulips in unmodified sunlight. Although acceptable, it isn't very interesting. On the right, the same grouping has a dappled light from the branch of artificial foliage held above the blooms. The change is fairly subtle, but upon close examination you will see that the highlights on some blooms have been markedly reduced and there are shadows on some of the foliage. Overall, it's a more pleasing look.

Kodak E100S, f11½ at 1/60th second

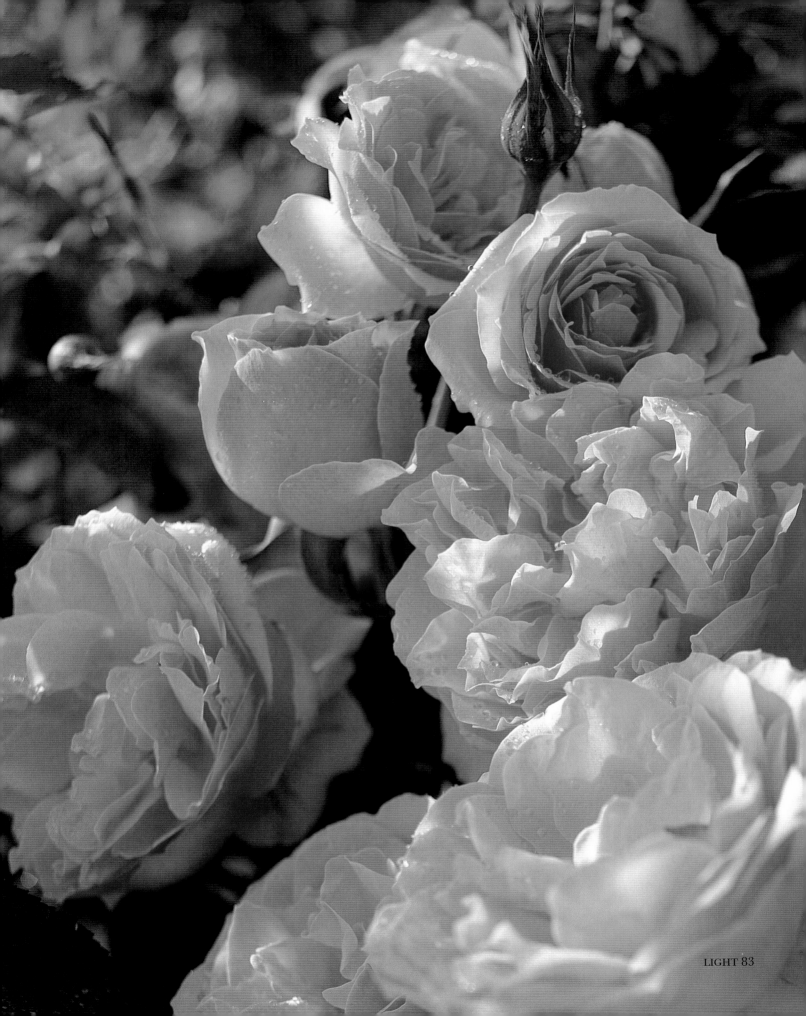

DIRECTION OF LIGHT

How light falls on a subject makes an enormous difference to the impact of the final image. The three photos at right show just how three different positions of the sun change the look completely. All were taken at the same time of day, mid-morning. The only difference was the direction of light relative to the camera position.

In the photo at top left, the sun was almost directly behind the camera creating a strong front light. This is the least desirable illumination as it tends to flatten the image as well as washing out the colors. The contrast between light and shadow is very strong and not at all flattering. I can think of almost no instance in which I would prefer this kind of light.

The center photo has the sunlight coming from the right side of the camera position. Sidelight gives much more dimension to tulips and certainly is a much better alternative to frontlight. It does, however, leave the shadow areas quite dark and generally requires a fill card (which I did not add to any of these three photographs) to help brighten those spaces.

In the top right photo, the sun was almost directly behind the subject – virtually facing the camera. Backlight, such as this, is really my favorite way to illuminate almost any garden photograph under sunny conditions. It results in the richest colors and has a way of reducing contrast between light and dark areas of the plants. When the light shines through flower petals and foliage, they almost glow and it reinforces their translucent and delicate nature. A potential problem that will be encountered is that the highlights may actually become mildly overexposed due to the adjustments made to get the shadow areas exposed properly. In this situation, a fill card is almost mandatory to reflect light into the front to keep the contrast between the highlight and shadow areas from being too great. An additional caution is that the front of the lens must be shielded from the sun with either your hand or a dark card. This shading, depending upon the angle of the sun, usually must be fairly close to the lens. Be sure to avoid getting it into the actual frame of the photo, a mistake I've made more than once.

Pictured right: The strong backlight coming through the petals of this rose makes it absolutely luminous. It gives the bloom wonderful dimension that almost jumps off the page. Kodak E100S, f8½ at 1/60th second

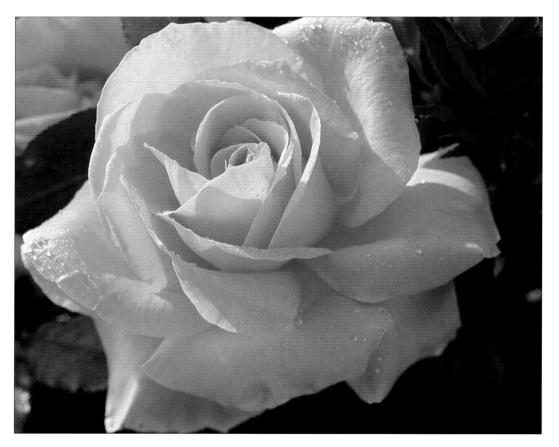

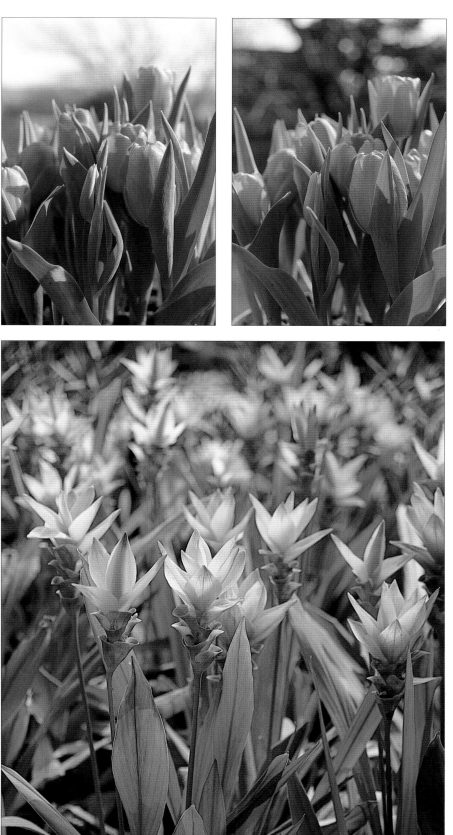

Pictured bottom right: The Siam tulips in this shot look almost like porcelain with the strong light coming through from behind. Adding a brilliant contrast is the bright green of the backlit foliage that otherwise has a somewhat drab gray green shade when illuminated from the front.
Kodak E100S, f11 at 1/125th second

QUALITY OF LIGHT

Light is the core of photography. The quality of the light affects the entire character of a photograph. Although I have a definite preference for the bright sparkling light that the sun provides, shooting in overcast or even shady situations is not necessarily bad. The two images on these pages reflect the dramatically different looks that are possible.

Pictured below: Bright sun on the front rudbeckia bloom below contrasts wonderfully against the shadowy, dappled light on the flowers behind to emphasize the brilliant morning light. The photograph has a real sparkle to it.
Kodak E100S, f8 at 1/60th second

Pictured opposite page: These rosehips were shot late in the day when the sun had gone low in the sky behind the nearby trees. It seemed that the opportunity for a shot had passed for the day, but something about the softness of the light still caught my eye. Though requiring a much slower shutter speed than I like to use outdoors, the air was remarkably still so I could proceed. The results are striking with the warm autumnal colors combining with the bright almost neon greens. Bright sunlight probably would not have been nearly as effective in this particular photograph.
Kodak E100S, f5.6 at 1/8th second

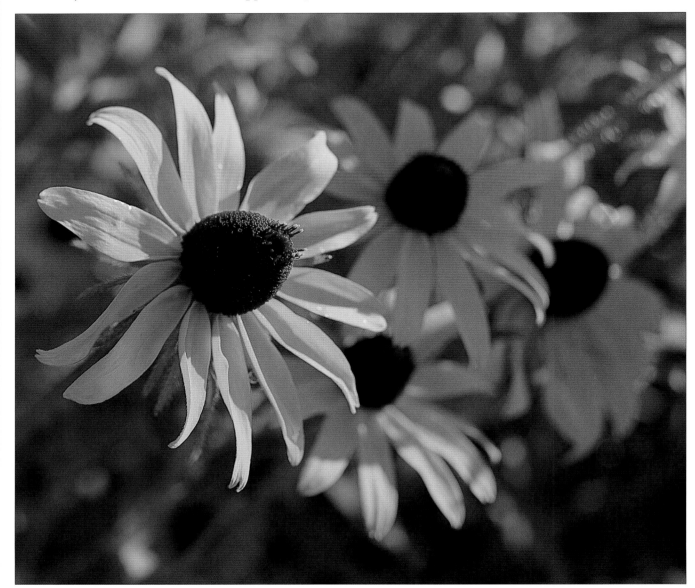

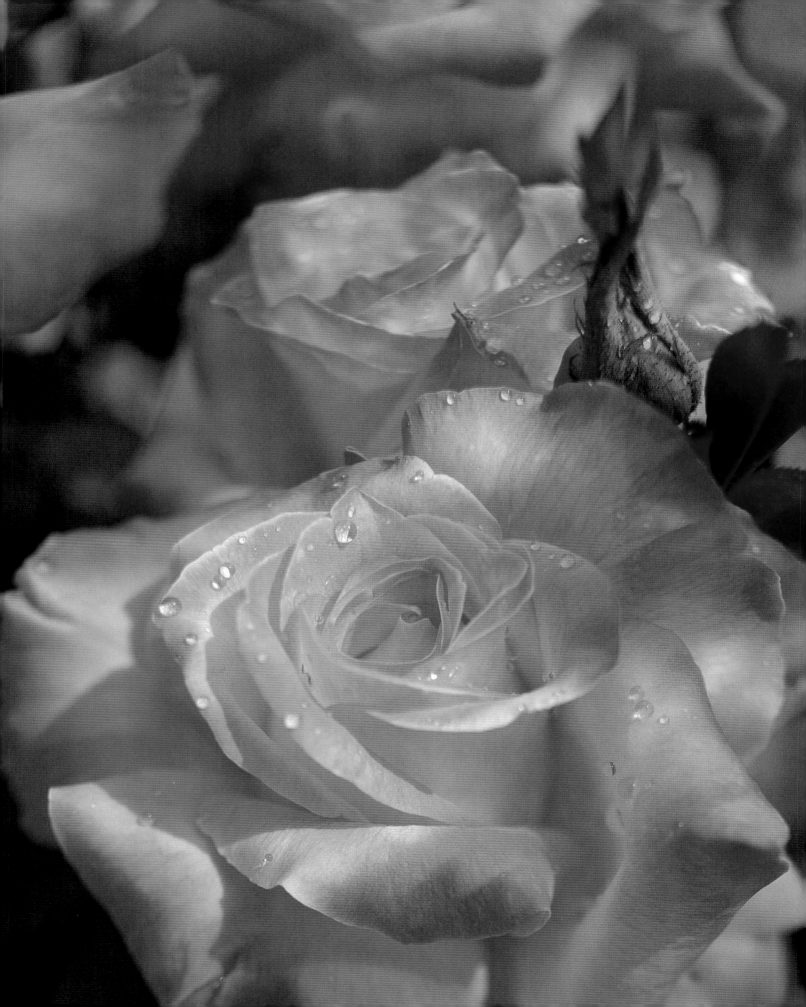

Pictured opposite page: For the soft appearance of these roses, I used a combination of a diffuser to reduce the contrast of the sunlight and also added some light dappling of shadows. The relatively shallow depth of field also helped to soften it.

Kodak E100S, f5.6½ at 1/60th second

Pictured right: To strongly emphasize the bright sunlight and enhance the light coming through the leaves and petals of this clematis, I chose not to use a fill card. The result is a greater level of contrast between light and dark, but it also made for very rich colors.

Kodak E100S, f11 at 1/60th second

Pictured below: These blue grape hyacinths were shot early in the morning when the very low angle of sunlight was just catching the edges of the bloom clusters, giving the plants a wonderful sparkle. Using only a small amount of reflected fill light, I was able to capture the intensity of color.

Kodak E100S, f8 at 1/30th second

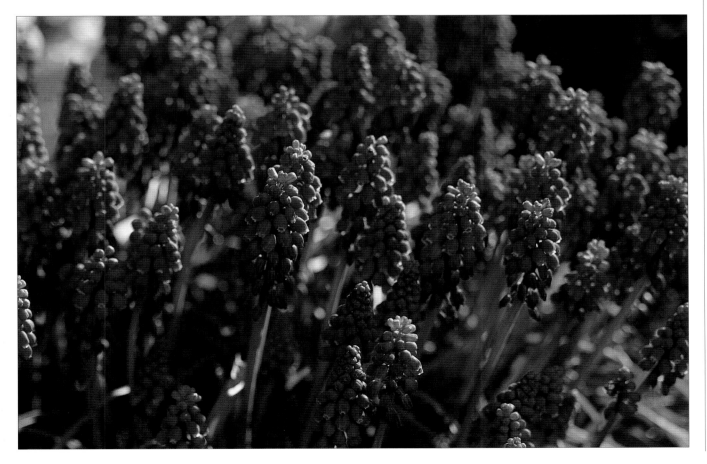

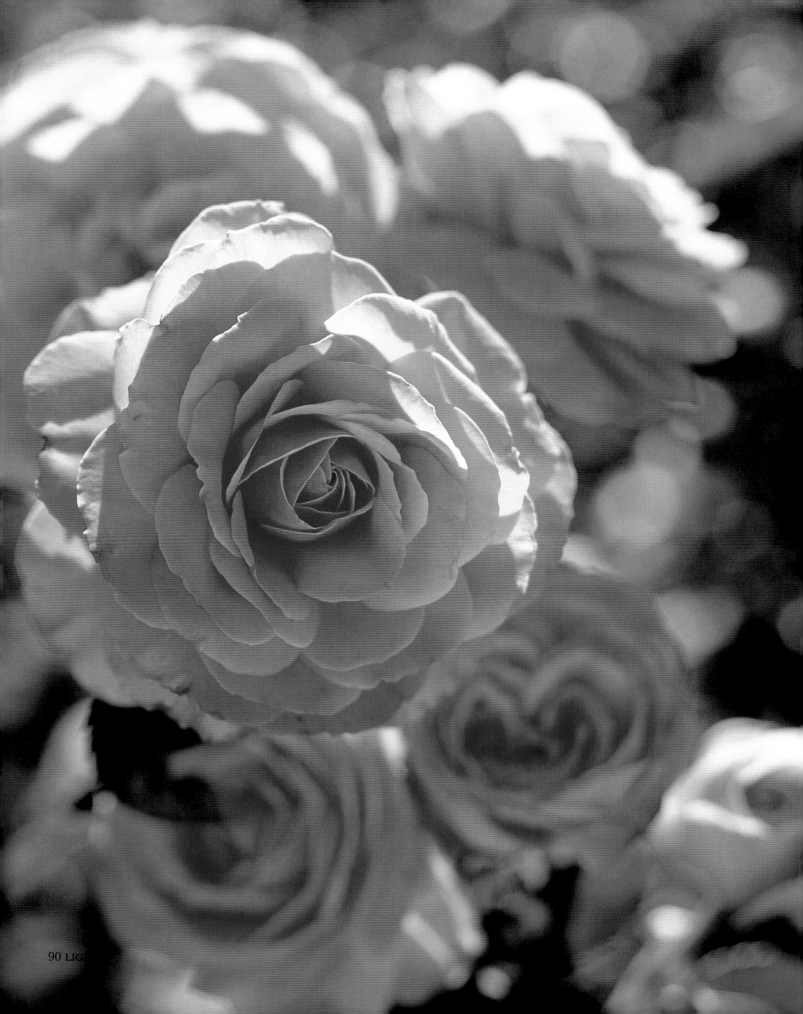

Pictured above: The soft, overcast light on this mixed English bed keeps the photograph from becoming too busy. Sunlight, though brightening the colors, would also add much more contrast between the highlight and shadow areas, making the appearance much harder.
Fuji Velvia, f5.6 at 1/30th second

Pictured left: This photograph has a very limited color range, from white through yellow to green. The soft light helps the colors work together as a much more intimate composition.
Kodak E100S, f8 1/2 at 1/60th second

Pictured opposite page: Here I have let the sunny highlights become slightly overexposed to create the feel of very bright morning light. The shallow depth of field lets the background blooms and foliage of the rose become little more than colorful shapes to support the main bloom.
Kodak E100S, f11 1/2 at 1/60th second

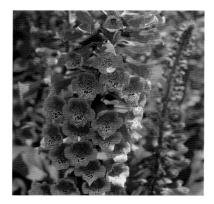

STYLING

Though much of the beauty of garden photography lies in the capturing of the subject in its natural form and setting, sometimes you just won't find that "perfect" specimen or composition. The answer is in styling, using various tools to enhance the subject and glamorize it, if you will.

Styling can have a number of meanings, but in the case of garden photography, it is a matter of making the subject look "perfect," which could be either completely unblemished or artfully rustic. Think of garden photography as a form of glamour photography. We've all seen those glamour photos of rather ordinary people who, after having been made up, dressed in stylish clothing, and given a few props, look like movie stars. Well, styling in garden photography is really the same process. You can take a nice but ordinary subject and make it glow with just a bit of styling and a few tricks.

STYLING TOOLS

There are a number of tools I carry along when I'm shooting in the garden. It's really quite rare to find the plants or flowers exactly right to be photographed. Now, that is not to say that every bloom must be perfect and every arrangement set up "just so." Often what I do may be as little as using some wire to nudge a blossom into a better position for the composition or just a dusting off to remove unwanted specks of dirt. Then again, there are times I will build a shot virtually from scratch using almost every trick I can, so it's handy to have everything along, just in case.

Carrying Case

My styling kit, pictured right, is kept together in a compact fishing tackle box. It has just enough room and compartments to stash everything, it is easy to transport, and it is secure. My box, though a little worn around the edges, has been to many gardens around the world and has served me well.

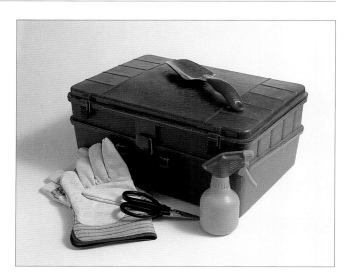

Basic Tools

Garden shears will be invaluable to remove spent foliage and for moving elements around when completely restyling a subject.

Scissors: I carry two sizes of scissors – large for bigger cuts but still more delicate than would be done with the shears, and very small for careful trimming.

Garden trowel is a helpful tool in many ways when needing to move dirt or rocks; or even replant a specimen.

Garden gloves are helpful to protect your hands.

Pliers, Screwdrivers, and a good Utility Knife: Though these are not often used, they come in handy in some instances.

Plastic trash bags are essential to clean up after yourself and also for emergency use to cover equipment in a surprise rain shower.

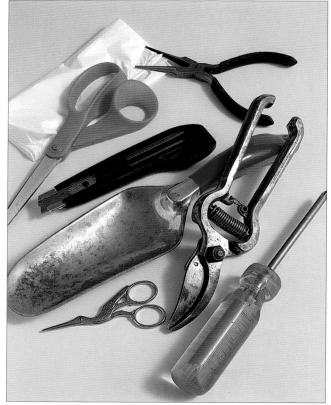

Pictured left: Clockwise beginning at upper left: Basic tools - plastic trash bag, large scissors, pliers, garden shears, screwdriver, small scissors, trowel, utility knife.

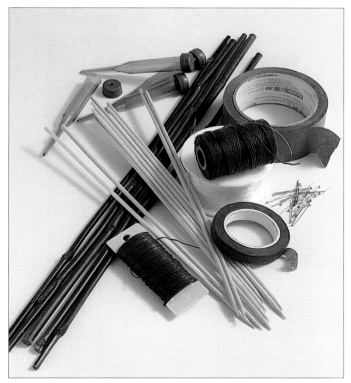

Pictured above: Clockwise beginning at upper left: Styling materials - water pics, plant stakes, masking tape, twine, fishing line, straight pins, floral tape, skewers, floral wire.

Pictured above: Clockwise beginning at center: Subject enhancement materials - leaf shine, artist brushes, camouflage fabric, spray bottle for water.

Styling Items

Wire and twine: a spool of thin, flexible wire as well as some clear fishing line, and string or light twine are needed. These are useful in pulling branches into or holding them out of a frame.

Bamboo skewers and small plant stakes are very helpful for holding flower or foliage stems up in good position to fill "holes" in your composition.

Water pics, which are available from most craft stores with floral supplies, are ideal to hold a cut stem in water to keep it from wilting.

Straight pins and regular masking tape may also be useful from time to time.

Subject Enhancement Materials

Two or three artist brushes in various sizes with soft bristles are perfect for brushing off errant dust, pollen or other distractions from delicate blooms.

A **leaf shine product** is very good to shine up foliage that may have water spots left on them. Most of these products are not harmful to plants, but be sure to follow all label instructions.

A **water spray bottle** is a must. I never go anywhere without my spray bottle to add that "fresh morning dewy look." You have seen water droplets on many of the images throughout this book. Although some are, indeed, genuine morning dew, many have been midday or afternoon shots in which I have sprayed a fine mist of water to recreate the look of the morning.

Green camouflage fabric or other green leafy patterned cloth may seem odd to have but will be very handy. I carry just a small piece, about three or four feet square. I can't possibly tell you how many times I've been in a situation where my "perfect" subject has been in the middle of a completely unattractive expanse of dirt or other distractions. Draping the cloth over the ground and letting it go out of focus will give the appearance of green foliage in the background.

Building a shot from scratch

It's not often that I start from nothing and build an entire shot, including the plant, but in some situations it is the only way to get the photo. The most important thing to remember when doing this is that you should always keep in mind the real growth habit and form of the plant you are creating. Never build it in a way that would not be possible in nature.

The photograph of the dahlias shown here was one of these cases. The dahlia was growing in an impossible location that received terrible light for a good shot, and the plant itself and background were not attractive. So, I decided to recreate it in a better spot. The successful result of this is, I hope, the realization that if I had not been revealing the process here, the shot at right and on page 93 would have seemed perfectly normal and "unstyled."

This all seems like a lot of trouble for a single photograph and it is probably unlikely you would ever go to such lengths, but it does illustrate many of the styling tricks and tools you can use in various circumstances.

Here are the skewers and plant stakes, water pics and floral tape used in building this arrangement.

Pictured above left: I cut the stems of blooms from the original plant and placed them immediately into water pics to keep them from wilting. The pics were then attached to three green stakes with the floral tape. This allowed me to elevate the cut blooms to a higher position.

Pictured above right: Just before I was ready to shoot, I cut some additional smaller flowers to use as foreground color. They too were attached to a plant stake with floral tape to lift them high enough to be in the frame. Since I knew they would only be cut for a few minutes, there was no danger they would wilt so I did not use water pics for them, though it would have been possible.

Pictured left: Here you see a wider view of the complete setup for this image. The camera is set on the tripod for the vertical image with the blooms arranged appropriately. To the right is my white fill card to help reduce harsh shadows, and a branch of fake foliage is held above on an arm from a stand to create dappled shadows across the blossoms. In the upper left corner is my background camouflage cloth covering the base of a sundial which was a distracting, element.

STYLING A SINGLE ROSE BLOOM

Sometimes, the blossom you want to photograph looks interesting or has nice form, but there are damaged petals or blemishes that make it less than perfect. In this sequence, you can see some of the methods I use to rehabilitate such blooms.

Pictured right: This rose has a good basic form and color but there are many areas of damage on the petals.

Pictured below left: To remove badly damaged petals, firmly grasp it as far to the center of the bloom as possible and pull it gently. This should bring it out completely from its base.

Pictured below right: If you have removed a petal, it must then be replaced with a petal from another bloom. The replacement should be the same size as the original and the color should match closely as possible. To get it to fit into the space, it is helpful to cut the bottom tip off; otherwise it will not go all the way back into the original position. Gently slide it into its spot.

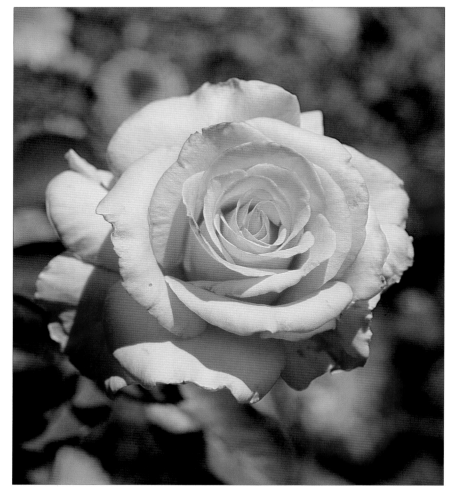

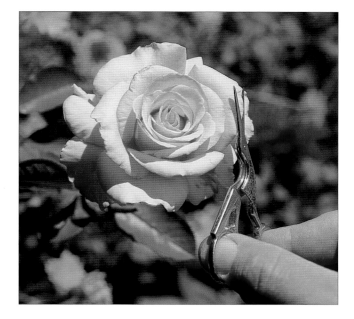

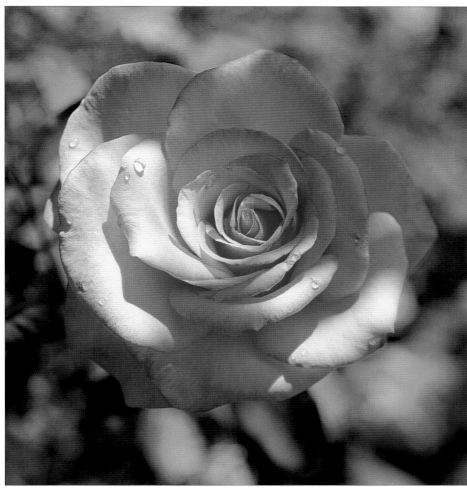

Kodak E100S, f11 at 1/60th second

Pictured above left: A method to remove small damage at the very edge of a petal is to carefully trim it away with tiny, very sharp scissors. This should only be done to remove the tiniest bit of damage as cutting too much will leave the petal misshapen.

Pictured above right: For small surface blemishes, I will often disguise them with droplets of water applied carefully with an artist brush. Loading the brush with the proper amount of water takes practice, but with a very gentle touch to the blemish that is being hidden, a small drop of water will be left behind.

Pictured left: With some shadowing to break up the rather harsh light, the shot is complete. Not all of the blemishes have been completely covered. That is fine in many circumstances. Sometimes blooms can be made to be too perfect and become unreal in appearance. The styling on this bloom, though fairly extensive, took it from a rather rough condition to a very nice look.

REPAIRING DAMAGE TO A DAHLIA

This dahlia had a very nice form and would make a great single bloom image, but it had an obviously torn petal on the left side as well as some on the right that had been chewed by insects.

As with the rose on the preceding pages, I removed the damaged petals by gently tugging them out of their position.

Replacement petals, with their bases slightly trimmed so they would fit, were inserted where the damaged ones had been removed.

Pictured opposite page: The final "perfect" bloom.
Kodak E100S, f8½ at 1/60th second

BEING READY FOR ANYTHING

The rewards of garden photography are many, including the opportunity to spend hours among beautiful plants and flowers in often lovely weather. What could be better? How could there possibly be a downside? There are many.

With an assignment to shoot these colorful lupines and just one possible day on which it could be done, I traveled the three hours or so to the nursery. The day had begun fine, but as I approached the shoot location, gray clouds filled the sky and it began to rain very hard.

With no choice but to get the shot that day, it was time to put on the rain gear and get wet. To have some look of sunlight, it was necessary to bring out the strobe lights, which, with the high power and danger of using such electrical devices in the rain, didn't excite me. I was just glad I had thought to bring them along.

In the end, it worked fine and my client was pleased, but I suppose the moral to this story is to always be prepared for any possibility when shooting outdoors. Use of the strobes in this kind of wet weather is not something I recommend and is likely more equipment than you have.

Pictured below: The area surrounding the plantings was pretty barren, so there was a limited shooting angle and we had to bring in a lot of other green plants to fill up the background. You can see the makeshift rain cover over my strobe light on the left and the plastic garbage bag covering my camera.

Pictured below and opposite page: Even though this was a gloomy, wet day, I was successful in getting a pretty good shot. I had to use a very slow shutter speed to get the right exposure. Since there was a lot of movement with the rain, I shot many extra frames and bracketed widely to ensure that I would get it on film without any blurring movements.
Kodak E100S, f5.6½ at 1/15th second

VISITORS IN THE GARDEN

Capturing the perfect bloom or getting just the right light makes such a difference, but the one thing that can add even more interest to garden photography is capturing the garden's visitors.

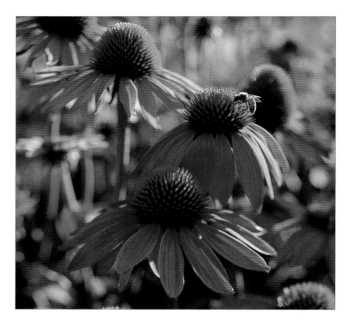

Pictured right: Bees move quickly and are difficult to catch in your shots, but just that little bit of liveliness they add can be magic as with this shot of Echinacea. It requires a fast shutter speed and a cooperative bee that stops just long enough.
Kodak E100S, f8 at 1/125th second

Pictured below: It was hard to see this frog among the water lilies just below one of the blossoms, but that's part of what makes it a successful image. It is the element of surprise when you first look at the plants and then realize that you, too, are being watched.
Kodak E100S, f11 at 1/60th second

Pictured left: These two cats enjoying a lazy summer afternoon on a shady windowsill were just too hard to resist. One seemed a bit annoyed that I would be taking a picture of it while the other was more interested in a bird in a nearby tree. Kodak E100S, f8 ¹/₂ at 1/60th second

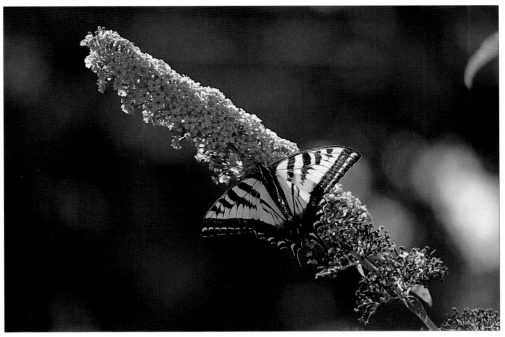

Pictured above right: Many people, myself included, have an aversion to spiders, but they play an important role in the garden system. This rather large spider sitting in wait really caught my eye because the backlight on the dew covered web made such a wonderful pattern against the out of focus background. Kodak E100S, f5.6 ¹/₂ at 1/60th second

Pictured above: The bright yellow color on this butterfly against the pink buddleia and green background makes a wonderful photograph. Kodak E100S, f11 at 1/60th second

PROJECTS

Creating beautiful photographs is really only part of the fun. Once you have stacks of lovely images, it's time to enjoy them. There is the obvious choice of placing them in an album, which is fine, but they tend to be put away on a shelf and forgotten over time.

Why not put them to work? They can easily become a part of your gardening lifestyle. You can bring the garden indoors in the dreary winter months with framed images on the walls. Or, create very personalized note cards, a way to share your garden's delights with friends. The possibilities are virtually limitless. Ideas in the following pages are just the beginning. I hope they spur your imagination to make many more uses of the images you create.

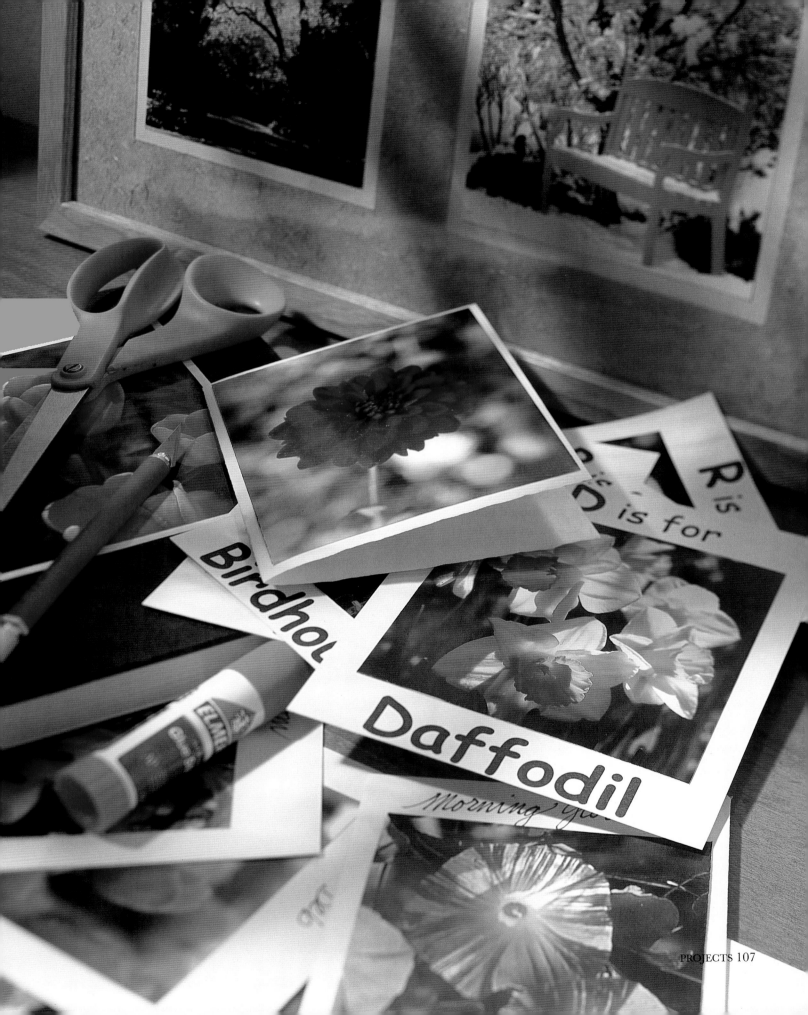

NOTE CARDS

There are many wonderful cards on the market for all occasions, but often, they seem just a bit impersonal or maybe not exactly right for your needs. One of my favorite ways to make use of my garden images is to create my own note cards. They are a wonderful way to share the beauty of your garden with friends and family and a perfect keepsake from you. The photo on the front was created by you and the message inside is all your own. These cards can be made for any possible event.

Items Needed:

- Blank note cards and envelopes, available from most stationers and art supply stores.
- Glue stick for attaching the photo
- Scissors
- Several photographic prints, either 4x6 or 3 1/2 x 5 depending upon the size of the blank note cards you have.

Putting It Together:

1. Simply select a photo to use on a card. Set it on the front of the blank card to see how it fits. Ideally, you should have a border of 1/8" to 1/2" all around the image.
2. If the fit isn't exactly right, use the scissors to trim the photo to a size that allows an even border all around. My cards here were 4-1/4" x 5-1/2" and the prints were 4"x6", so I trimmed them to a size of 4" x 5-1/4, which left a 1/8" border.
3. Use the glue stick to apply an ample amount of adhesive to the back of the photo and press into place.
4. Finally, write your notes and send them off, but be prepared for all your friends wanting note cards they can use for themselves. ❏

FOUR SEASONS PHOTO MONTAGE

This is an interesting project that begins with a year-long effort to collect images that capture your garden in all four seasons.

There are a couple of different approaches that can be taken. The first is to select a viewpoint that has some interest that, although changing, will have some of the same elements throughout the year. For example, include a bench, birdbath, or garden sculpture. In each season photograph the spot from the same location, making notes with the first shot about where it is so the camera can be placed correctly each time. Each seasonal photo should show the character of the season; green with flowers for Summer, colored foliage in the Fall, snow or ice in the Winter, and early blooms or buds in the Spring.

The second approach that can be taken, which is what I've done here, is to use one photograph from each season that truly typifies your garden in that season. These do not have to be the same subject or positioning. Just a composition for each that really speaks of the season.

Items Needed:

- Four 5"x7" prints (one for each season)
- 16" x 20" frame and glass
- One sheet of heavy weight buff colored paper
- One sheet of interesting art paper, handmade, or decorated is good
- Glue stick
- Art knife
- Ruler
- Double stick tape

Putting It Together:

1. Trim both sheets of paper to 16" x 20" to fit in your frame.
2. On the art paper (I used a handmade cotton paper with colored threads mixed in), mark four squares each measuring 5-1/2" x 7-1/2". To make them fit evenly, both sides as well as the top and bottom margins should be 1-3/4" wide. This will leave a space of 1-1/2" between each of the squares.
3. Using a very sharp art knife, carefully cut out the squares using the ruler or other straight edge as a guide.
4. With the double-stick tape, attach the paper you've just cut out to the buff colored sheet, carefully matching up the edges.
5. Using the glue stick, apply adhesive to the backs of the photographs and place them on the buff colored paper in the square cut-out areas. Be sure the photos are centered.
6. Place the completely assembled paper and photos in the frame with the glass and fasten in place with the hardware that comes with the picture frame. ❑

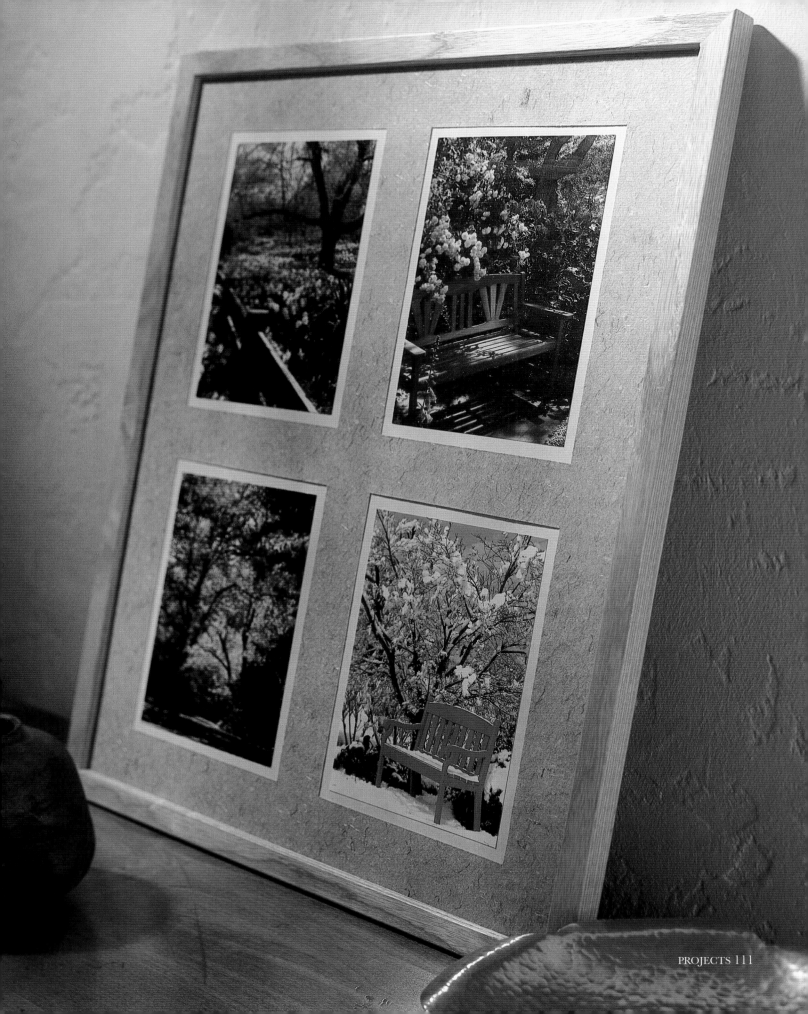

FRAMING YOUR PHOTOS

A great way to show off your work and to bring the garden indoors is to present the photos framed on the wall. They can be dramatic as a single large piece as I will discuss here, or as a grouping of several smaller photos together on a wall. The small framed photos also work well as a grouping on a desk or dresser in a guest room.

For this easy project, I have started with a single 8x10 print of a favorite shot of some red roses. I will be placing this picture in a 16" x 20" frame. This frame may seem too large for the photo, but you should remember that when framing photos they always look very elegant with a wide mat around the image. If you think of photos you may have seen in a gallery, they are almost always framed this way. Narrower mats tend to "cheapen" the appearance of the photo and give a far less dramatic appearance.

Pictured below: Collect your materials
Pictured far below: Hinging the window mat to the backing board.

Items Need:

- 8" x 10" photo in either vertical or horizontal format
- 16" x 20" frame. (I've selected a very simple black wood frame that will not detract from the image. There are many metal sectional frames on the market that would work just as well.)
- 16" x 20" window mat (I used an acid-free white mat board), cut by a professional framer. In this case, the window is 7-1/2" x 9-1/2" to allow the mat to overlap the edges of the photo. You could cut the mat yourself with an art knife and a straight edge, but you will not be able to get the nice beveled edge a pro can achieve, and it takes a great deal of practice to get it just right.
- One piece of foam core or other stiff board as a backing material cut to 16" x 20".
- Four photo mounting corners, available from any framer or art materials store.
- Tape for hinging the mat to the backing board.

Putting It Together:

1. Hinge the window mat to the backing board with two pieces of tape at the top near each edge as you see at right.
2. Close the window mat onto the backing board and slide your photo between so it is visible. Adjust it so there is about 1/4" of the photo under each side of the window. Without moving the photo, carefully open the window mat and lay it back out of the way. You may want to make very light pencil marks around your photo in case it gets shifted.
3. Use the self-adhesive photo corners to attach the photo to the backing board. Remove the backing paper from one photo corner. Without moving the photo, slip the corner tightly over the corner of the picture. Press it into place on the backing board, following the instructions on the package. Repeat this process for each corner.
4. Pull the window mat over the mounted photo.
5. Place the matted photo in the frame with the glass and fasten with the frames own hardware. ❑

A BUD-TO-BLOOM SEQUENCE

This project is a fun way to show the cycle of a bloom from bud form to fully opened. It can be done with almost any flower. In this case, I have selected a beautifully formed creamy white rose.

- To capture this sequence, I looked over many prospective buds to find one that looked to be in very good shape. The bloom would have to progress through several days and open well, so I selected carefully.

- This can be done with almost any color background, but for this nearly white bloom, I chose to use both black and white to illustrate how the background contrast affects the final image. I accomplished the photos by setting up the camera with a white card attached to a stand placed behind the bloom. The card needs to be far enough back to avoid having the rose's shadow fall on it. I made careful notes of where the camera and card were located so I could replicate the positions on succeeding days. To obtain similar light, it was also necessary to shoot at approximately the same time each day that the bloom had moved on to its next stage of opening. It can be a challenge to avoid unwanted foliage and shadows on the background. It may be necessary to use some twine to tie back other branches temporarily.

- For the black background, I draped a bit of black velvet cloth over the white card. Velvet is good to use because any highlights or reflections on it will seldom be picked up on film. It will provide a very deep, dark background.

- It is interesting to note how different the blooms appear on the white and the black. Each works in its own way, but they have a very different feel.

- For the final presentation, I had four 4x6 prints made – one of each bloom stage-and framed them in four matching frames. Although I selected black frames so they would not contrast too much with the image and to give a contemporary feel, you could use whatever works well with your décor. They can be hung either as a square group like I did, or in a long horizontal sequence, which can also be attractive. ❏

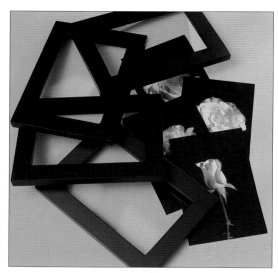

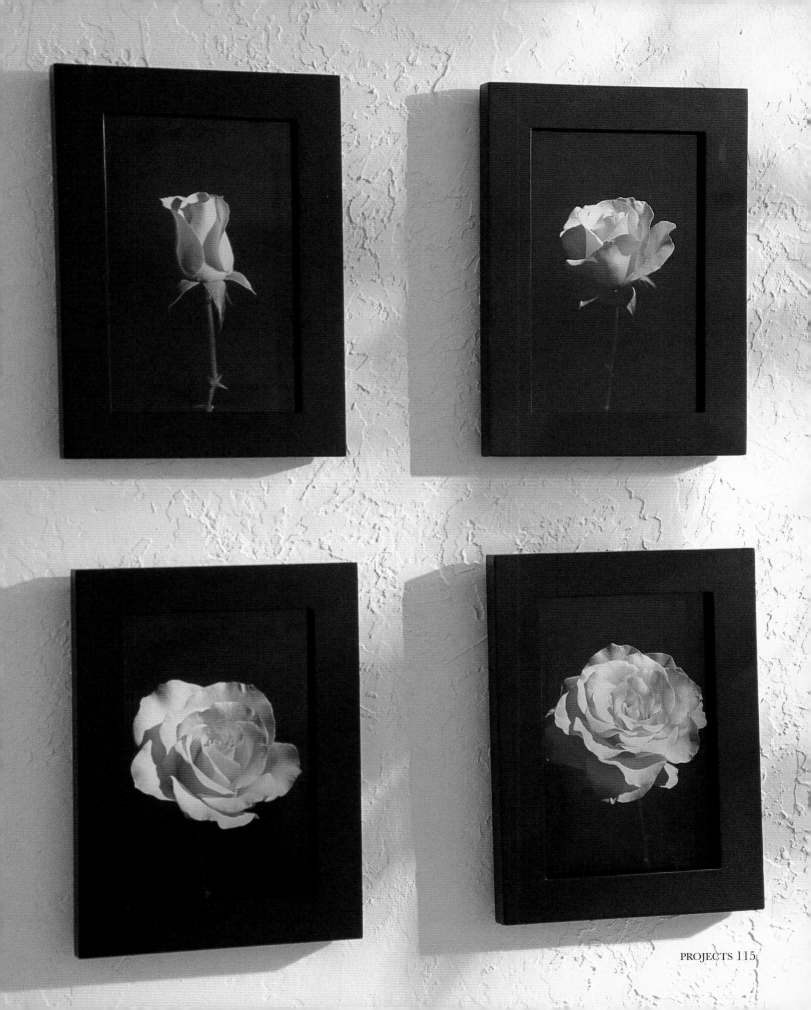

MAKE A SEED PACKET

Just about every gardener finds a favorite plant in their garden from which they collect seeds for the next season or to share with friends. Sometimes it is the collection of an antique or heritage plant whose seeds cannot be purchased. What better way to save them for the next year or to give away, than in a customized seed packet you've made yourself.

Items Needed:

• A photograph of the plant or flower from which you have collected the seed
• One sheet of paper (8-1/2" x 11" is perfect)
• Scissors
• Glue stick

Putting It Together:

1. Make an enlarged photocopy of the packet pattern on this page.
2. Trace the pattern onto the paper you will use to make the seed packet. I like to have the pattern on a piece of card stock so I can cut out the shape and trace it easily onto other paper for making many packages.
3. Carefully cut out the traced outline.
4. Fold along the indicated lines and glue the side and bottom flaps to the back with the glue stick.
5. Trim your photograph to fit on the front of the packet with a margin of about 1/2" on the top and bottom and 1/8" on each side.
6. Using the glue stick, glue the photo the packet.
7. Add the seeds, fold over the top flap, and glue the flap in place to seal the packet.
8. Be sure to write the name of the plant on the envelope and also your name so everyone knows where the seeds originated. ❑

Morning Glory

Grow Jerry's Garden

A GARDEN JOURNAL

Journals are always popular. They can be used for writings of many kinds and make wonderful personalized gifts. It is a project that is exceptionally easy to do. I use mine to keep detailed records of my garden and the progress of the plants from one season to the next. As plants are added, so grows the journal.

For my garden journal, I use two facing pages as a place to make notes about particular plants or areas in the garden. One page has a photo with notes about the image – film, aperture used, shutter speed, etc. I also make some notes about where it is planted, when planted, and so on. The other page is used for additional notes about its progress and changes.

If you wish to make this into a gift journal for your recipient to use as she wishes, just place photos on one of the pages and leave the rest blank. If you like, you could add favorite quotations, facts, or poems to further personalize the gift. The possibilities are virtually endless.

Items Needed:
- Blank journal with a plain cover, available at many bookstores or stationery shops
- Glue stick
- Sheet of white paper
- Scissors
- A favorite photo for the cover

Putting It Together:
1. For the cover, select a favorite photograph. The size you need will depend upon the size of the journal you have chosen. A 4" x 6" color print works well for many of the journals that are available. My book measures approximately 7" x 10".
2. Cut a piece of white paper 1/2" larger in both length and width than your photo. If you use a 4" x 6" photo, the paper should be cut to 4-1/2" x 6-1/2".
3. Using your glue stick, attach the white paper to the approximate center of the book cover, leaving equal spaces on each side as well as on the top and bottom.
4. Glue the photo to the white paper, leaving a 1/4" border of paper showing all around it. This will give the photo a nice frame. ❑

LILACS

(use this photo in a ...)

- Dark ...
- Medium ...
- Light ...

1997 – pruned dark bushes in June after blooming,
thinned old growth.
– planted medium-colored flowers, new.
– white bushes did especially well this
year! – came early in May

1998 – dark bushes showed poor blooms this
year – pruned last year.
– medium bushes had a few spikes –
still too young.
– another great show of the whites –
(gave a big bunch to Libby)

better dark flowers – recovered
...ooming –
...s were spectacular!
...the wet spring helped).

GARDEN ALPHABET CARDS

Kids love to be in gardens learning to plant things and watching them grow. This set of alphabet flash cards combines the learning of the letters with learning about plants in a fun way. The project is not too difficult and is a good way to get the kids involved in its creation as well.

It does take a bit of time to create and collect all of the photographs and sometimes creative thinking about the objects in a garden that represent each of the letters. On the other hand, it's this kind of goal that will get you really looking at everything in the garden, not just the plants, to find your photo subjects. Also, I've used a computer to print the words on the cards but they could just as easily be hand lettered if you don't have access to a computer.

Items Needed:

- 26 photographs, 4" x 6" size, each of an object starting with (or containing) a different letter of the alphabet. (Yes, "X" is going to be a challenge.)
- Card stock in white or any other color, available at a stationery or office supply store.
- Scissors
- Glue stick
- Pen for hand lettering or computer and printer

Putting It Together:

1. Trim each of the photos into 4" x 4" squares.
2. FOR HAND LETTERING: Cut out 26 cards that are 6" x 5". Write the letter with the plant name on the card, leaving a space in the center area of each card for the photo.
3. FOR COMPUTER LETTERING: Print out 13 sheets of paper with two cards on each. Each card should have the letter and the corresponding plant name as shown in the photos. Some word processing programs or desktop publishing programs will be able to do this. Cut out the individual cards after printing.
4. Using the glue stick, attach the appropriate photo to each card, centering it side to side and top to bottom so that the writing is not covered. ❑

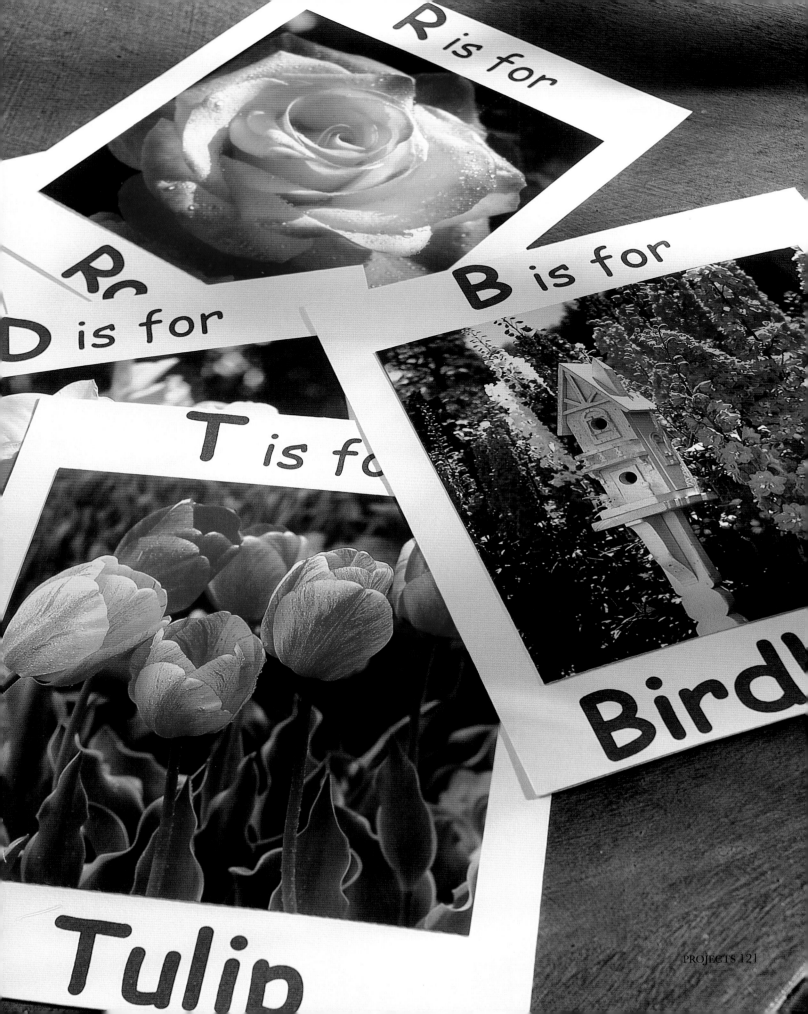

R is for

Rc

D is for

B is for

T is fo

Birdl

Tulip

A PERSONALIZED POSTER

Although this project takes a little more care in getting it laid out and put together, it can be a wonderfully graphic representation of your garden or that of a friend for whom this could be a gift.

Items Needed:

- 18" x 24" frame and glass
- One piece of art board (I used white mat board) cut to 18" x 24"
- 20 different 4" x 6" photographs
- Pencil
- Ruler
- Glue stick
- Scissors

Putting It Together:

1. Layout the positions of the photos on the board by first measuring 3-13/16" from both the top and bottom edges (18" side) of the art board and lightly draw a line all the way across the board. Be sure to make very light pencil marks as these will later be erased.

2. Measure 13/16" from each side of the board and draw a very light line in both places, just as far as the cross line made in step 1.

3. Measure the leftmost vertical line and lightly mark additional vertical lines in the following increments: 4", 1/8", 4", 1/8", 4", 1/8". This will give you four vertical rectangles, each 4" wide separated by 1/8" spaces.

4. Repeat the process in step 3, but these lines should be horizontal and your measurements should start at the bottom cross line. This will leave you with sixteen 4" square boxes separated by 1/8" spaces.

5. Trim each of the 20 photos to 4" x 4" squares.

6. Determine how you will arrange the photos by laying them on the grid of squares and moving them around until you have a satisfying appearance. Try to separate similar colors and shapes so that the final layout isn't too busy.

7. Using a glue stick, permanently place each photo into position, lining them up carefully on the light grid you drew on the board. When finished, erase any pencil lines that still show.

8. Either hand-letter the title or words of your choice in the top and bottom spaces or, as I did, print them out with a computer and printer and glue them into position. Either method works very well.

9. Insert your poster into the frame with the glass and use the frame's hardware to fasten it into place. ❏

Annie's Garden

Riverside Drive

PLACE CARDS

A wonderful way to help decorate Spring and Summer luncheon or dinner tables is with personalized place cards using photos of your garden's stars. They also make nice favors for your guests to take home to remember the occasion, and they are very easy to make.

Items Needed:

You will need quantities to match the number of guests.

- White or colored card stock (It can be white or any color that suits your décor. It's just most important that it be stiff enough to stand up in your particular place card holders.)
- 3-1/2" x 5" photos.
- Place card holders in any style.

Also needed:

- Glue stick
- Scissors
- Pen or pencil to write your guests' names

Putting It Together:

1. From the card stock, cut several cards to 4-1/2" x 6-1/2". You should have one for each guest.
2. Using the glue stick, attach one photo to each of the cards. They should be mounted to leave a 1/2 " border on each side as well as the bottom and a 1" space at the top where you will write your guest's name.

Options: The size and shape of these cards can be varied in many ways, including smaller borders, reduced size overall by trimming the photos, trimming the cards and photos into circles, and so on. Be limited only by your imagination. ❑

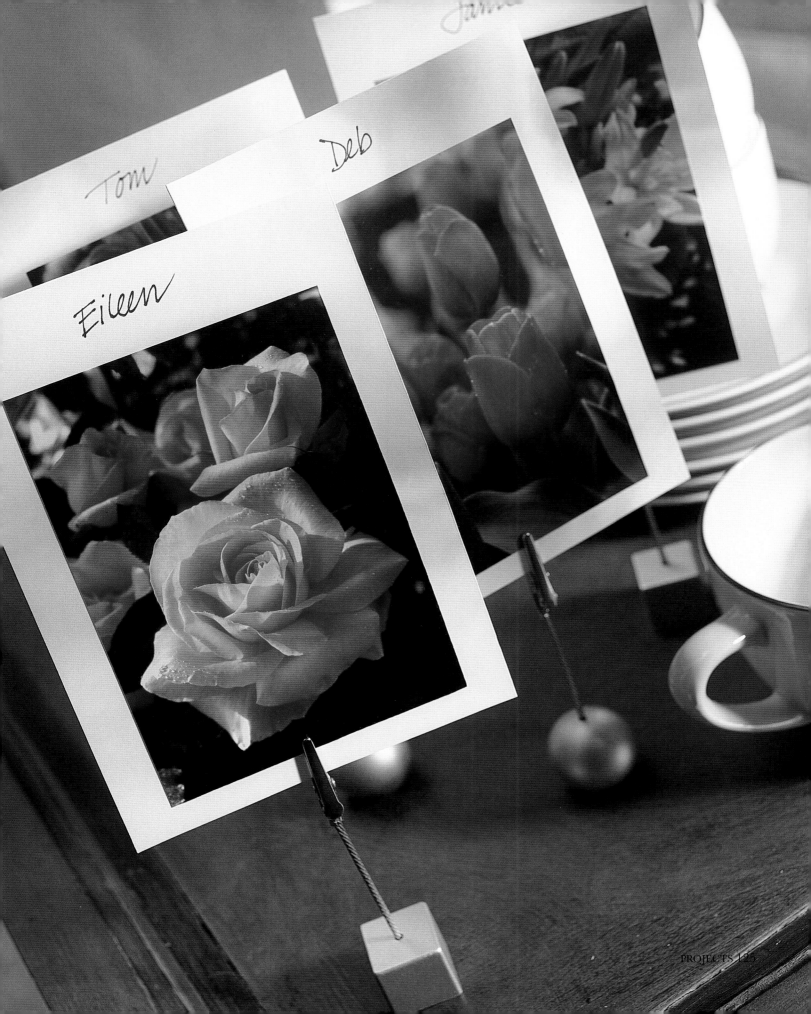

GARDENER'S T-SHIRT

Every gardener is proud of his or her creation, so why not show it off to the world? One of the best ways to do that is with a specially personalized T-shirt.

This is a project that can be done at home with a computer, scanner, printer, and special iron-on transfer paper made for computer inkjet printers. The instructions below assume you have this capability, but if not, many photo processing shops and custom T-shirt printing shops can do the work for you.

It may seem like a somewhat complicated process, so if it intimidates you, take your photos to a pro for the job. Having the personalized shirt will be worth the effort.

Items Needed:

- White or light colored T-shirt
- One sheet of iron-on inkjet printer transfer paper
- A computer with a photo editing or desktop publishing program
- A scanner
- An inkjet printer
- Four 4" x 6" photographs
- Scissors
- Iron & ironing board

Putting It Together:

1. With the computer, scanner, and program, scan and arrange the four photos into a square that is approximately 8" x 8" total. Each of the four images should be just under 4" square to allow a small space between them. Refer to your program manuals to do this.

2. Also using the computer, design the words that will be used on the shirt.

3. Following the manufacturer's directions, print out the photos and words on separate sheets of transfer paper. Your computer will need to be able to flop the images horizontally for printing, since the printing process will then flop it back to the original direction.

4. Once printed, trim the transfer sheets so that there is only a small border (1/8" or so) around the image.

5. Again, following the manufacturer's instructions, iron the transfers onto the T-shirt. ❏

METRIC CONVERSION CHART

Inches to Millimeters and Centimeters

Inches	MM	CM
1/8	3	.3
1/4	6	.6
3/8	10	1.0
1/2	13	1.3
5/8	16	1.6
3/4	19	1.9
7/8	22	2.2
1	25	2.5
1-1/4	32	3.2
1-1/2	38	3.8
1-3/4	44	4.4
2	51	5.1
3	76	7.6
4	102	10.2
5	127	12.7
6	152	15.2
7	178	17.8
8	203	20.3
9	229	22.9
10	254	25.4
11	279	27.9
12	305	30.5

Yards to Meters

Yards	Meters
1/8	.11
1/4	.23
3/8	.34
1/2	.46
5/8	.57
3/4	.69
7/8	.80
1	.91
2	1.83
3	2.74
4	3.66
5	4.57
6	5.49
7	6.40
8	7.32
9	8.23
10	9.14

INDEX